爷爷奶奶, ☺ thank you for guiding me !

DINGDING HU

DELICIOUS DAYDREAMS

a **seek**-*and*-**find**
for **foodies**

CHRONICLE BOOKS
SAN FRANCISCO

Shrimply the best day planning party

Friends, we gotta hang out soon! It's been too long, and I'm getting hangry.

When: Saturday, 5:00 pm

Where: Virtual Meeting Room

Who: The Hangry Girl Club

Metting ID: 859 440 5740
Passcode: Shrimp

Going: **Yes Maybe No**

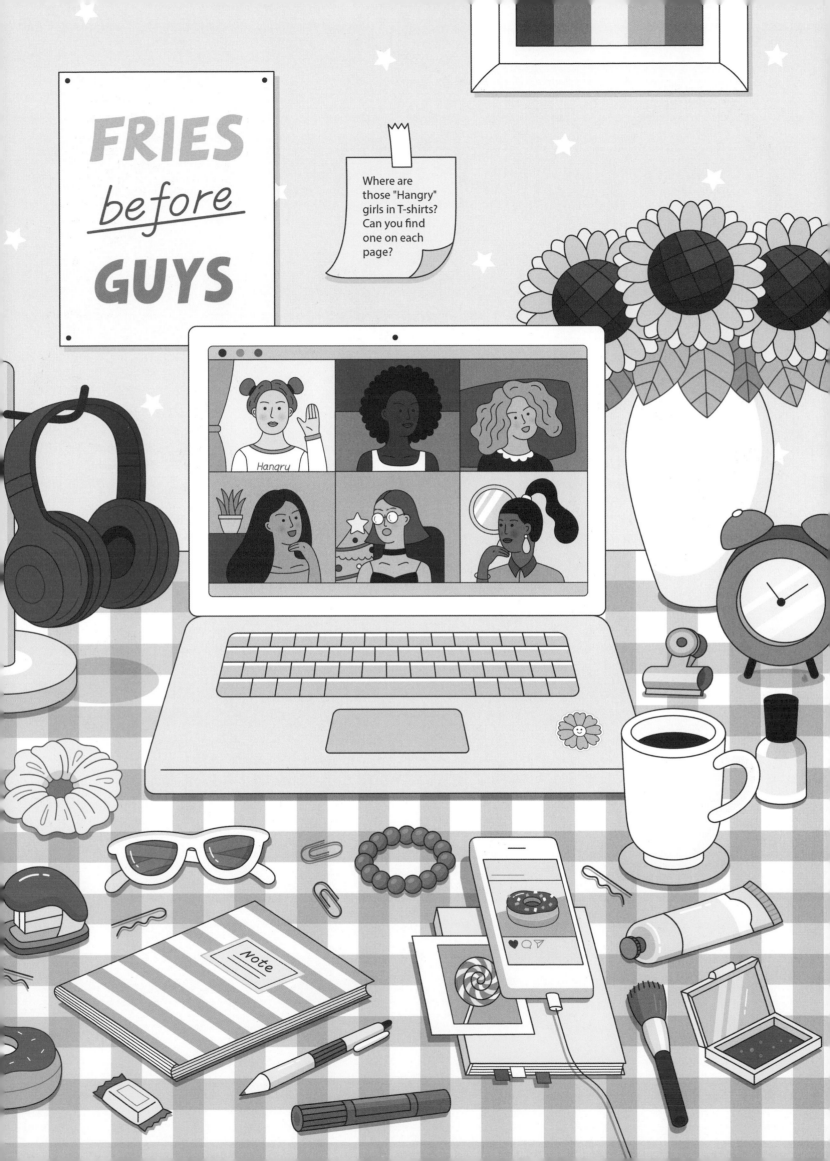

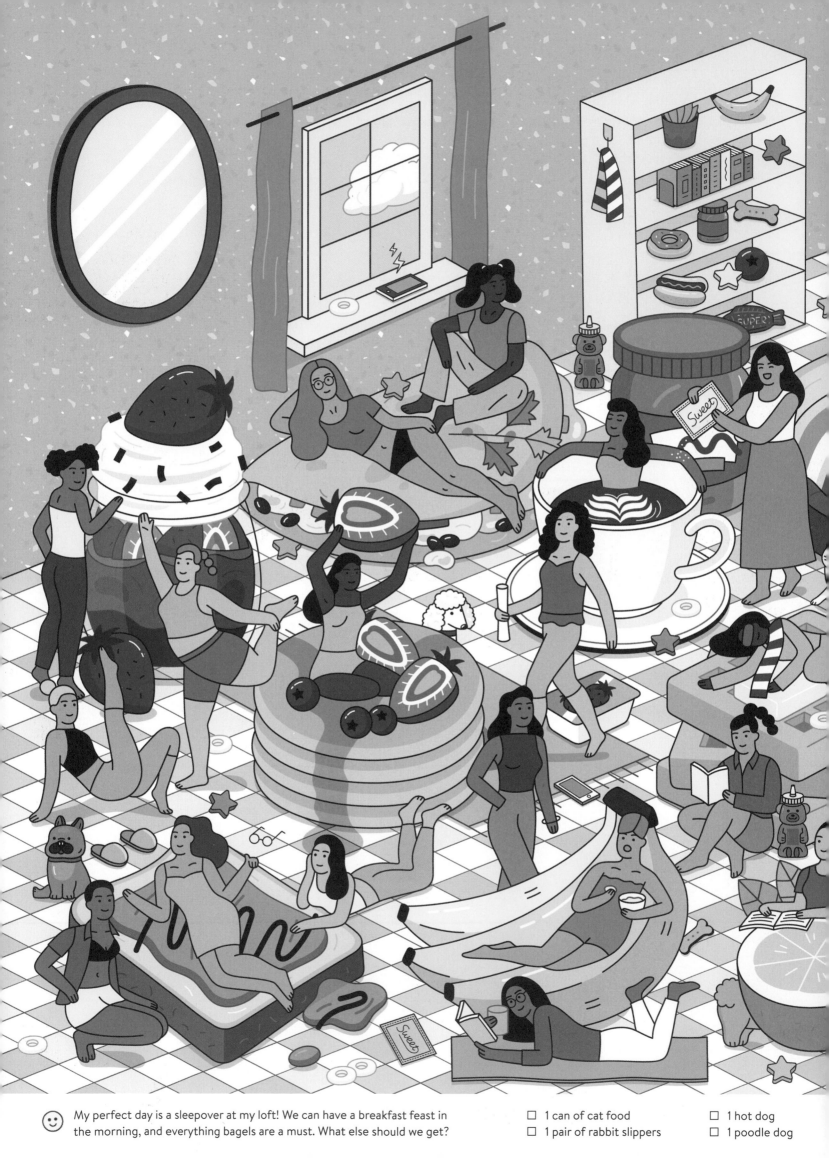

My perfect day is a sleepover at my loft! We can have a breakfast feast in the morning, and everything bagels are a must. What else should we get?

- ☐ 1 can of cat food
- ☐ 1 pair of rabbit slippers
- ☐ 1 hot dog
- ☐ 1 poodle dog

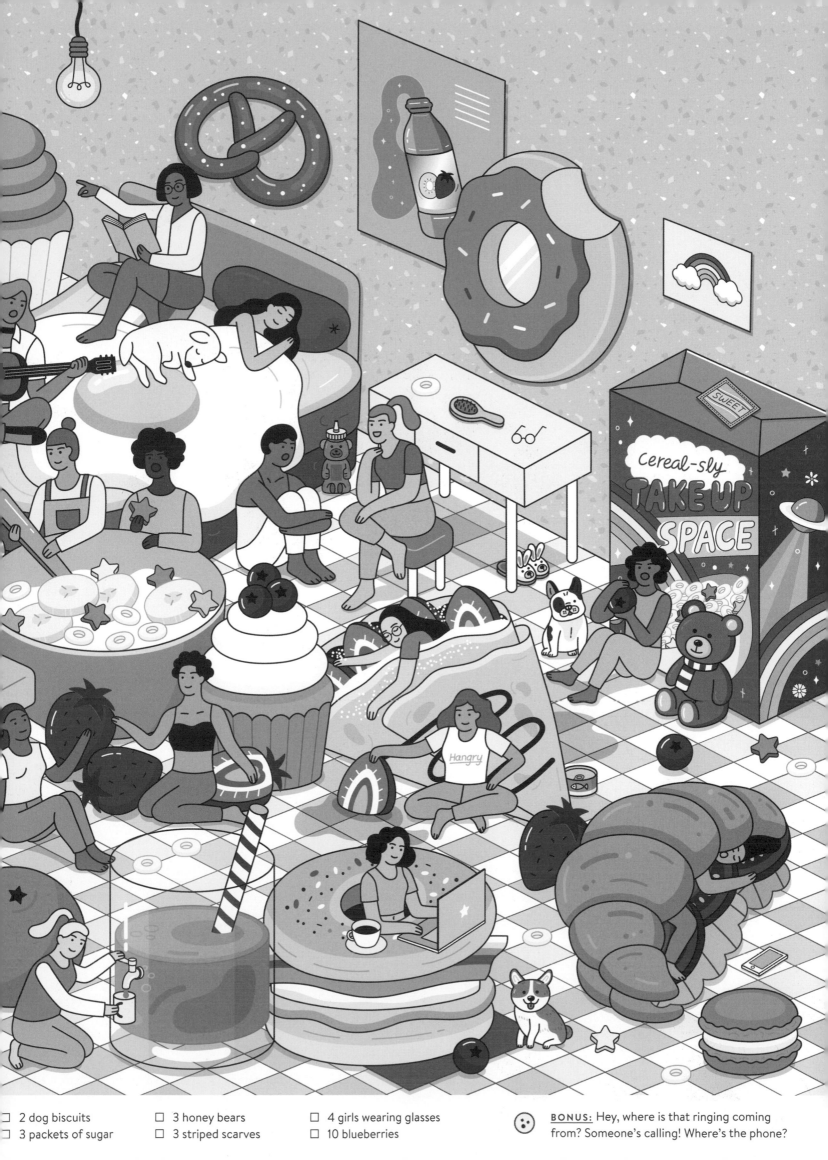

☐ 2 dog biscuits
☐ 3 packets of sugar
☐ 3 honey bears
☐ 3 striped scarves
☐ 4 girls wearing glasses
☐ 10 blueberries

BONUS: Hey, where is that ringing coming from? Someone's calling! Where's the phone?

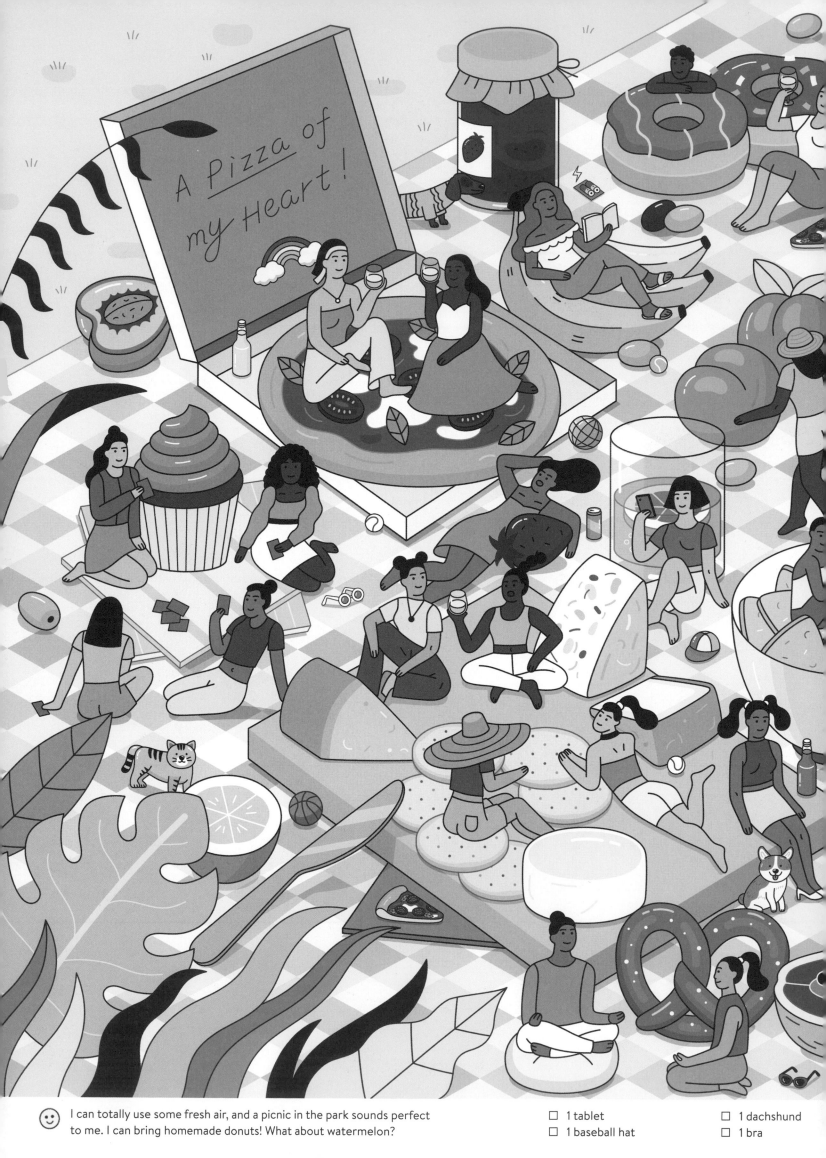

A Pizza of my Heart!

I can totally use some fresh air, and a picnic in the park sounds perfect to me. I can bring homemade donuts! What about watermelon?

☐ 1 tablet
☐ 1 baseball hat
☐ 1 dachshund
☐ 1 bra

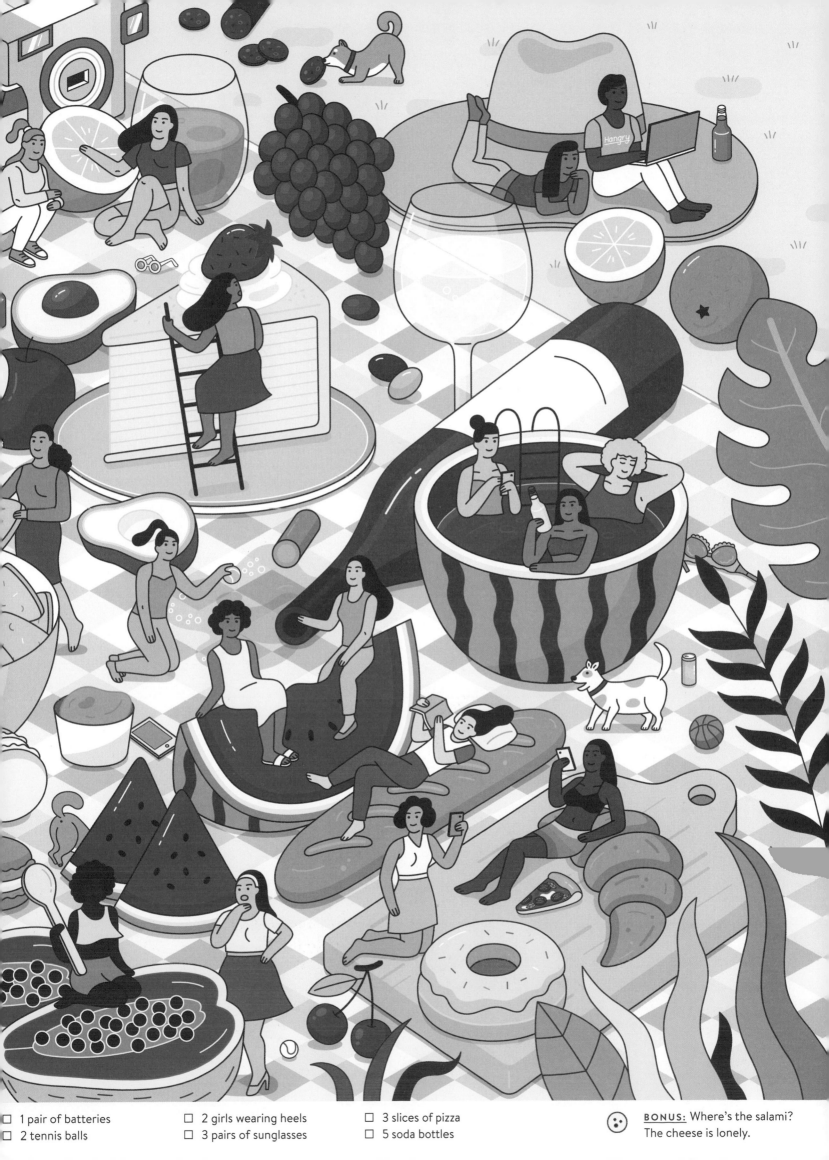

- ☐ 1 pair of batteries
- ☐ 2 tennis balls
- ☐ 2 girls wearing heels
- ☐ 3 pairs of sunglasses
- ☐ 3 slices of pizza
- ☐ 5 soda bottles

BONUS: Where's the salami?
The cheese is lonely.

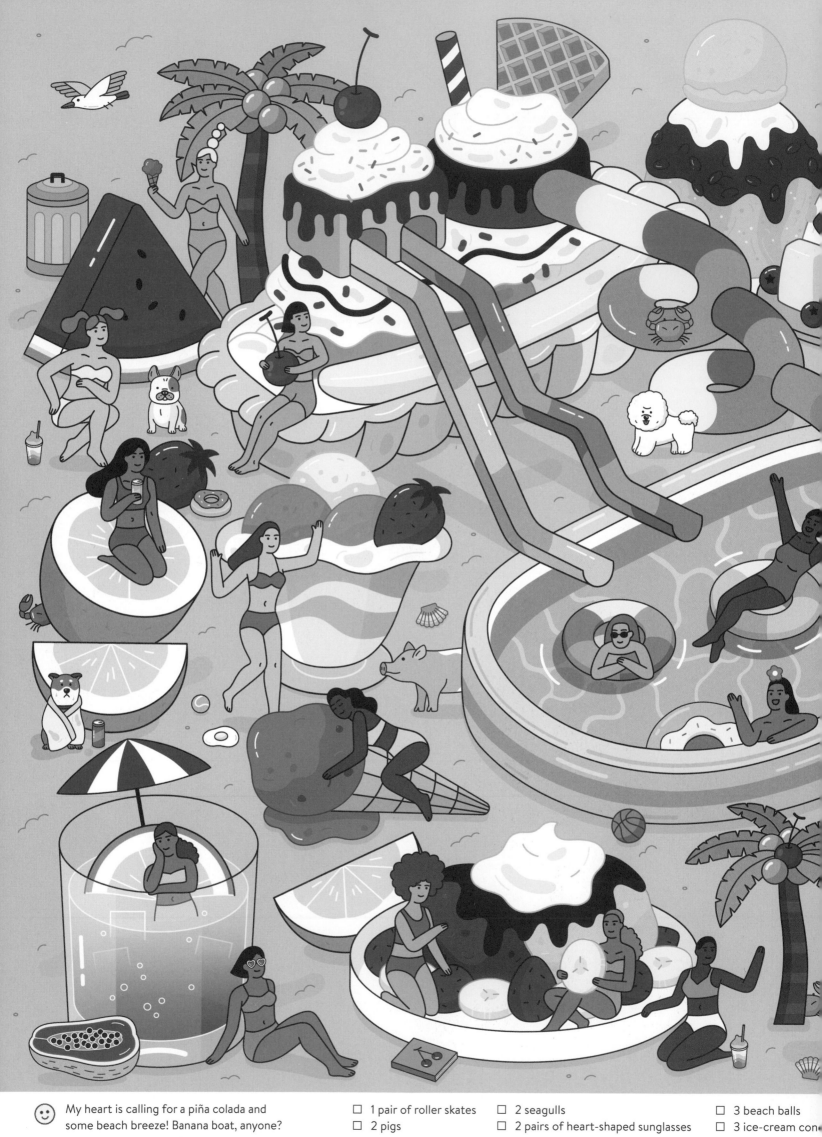

My heart is calling for a piña colada and some beach breeze! Banana boat, anyone?

☐ 1 pair of roller skates
☐ 2 pigs
☐ 2 seagulls
☐ 2 pairs of heart-shaped sunglasses
☐ 3 beach balls
☐ 3 ice-cream con

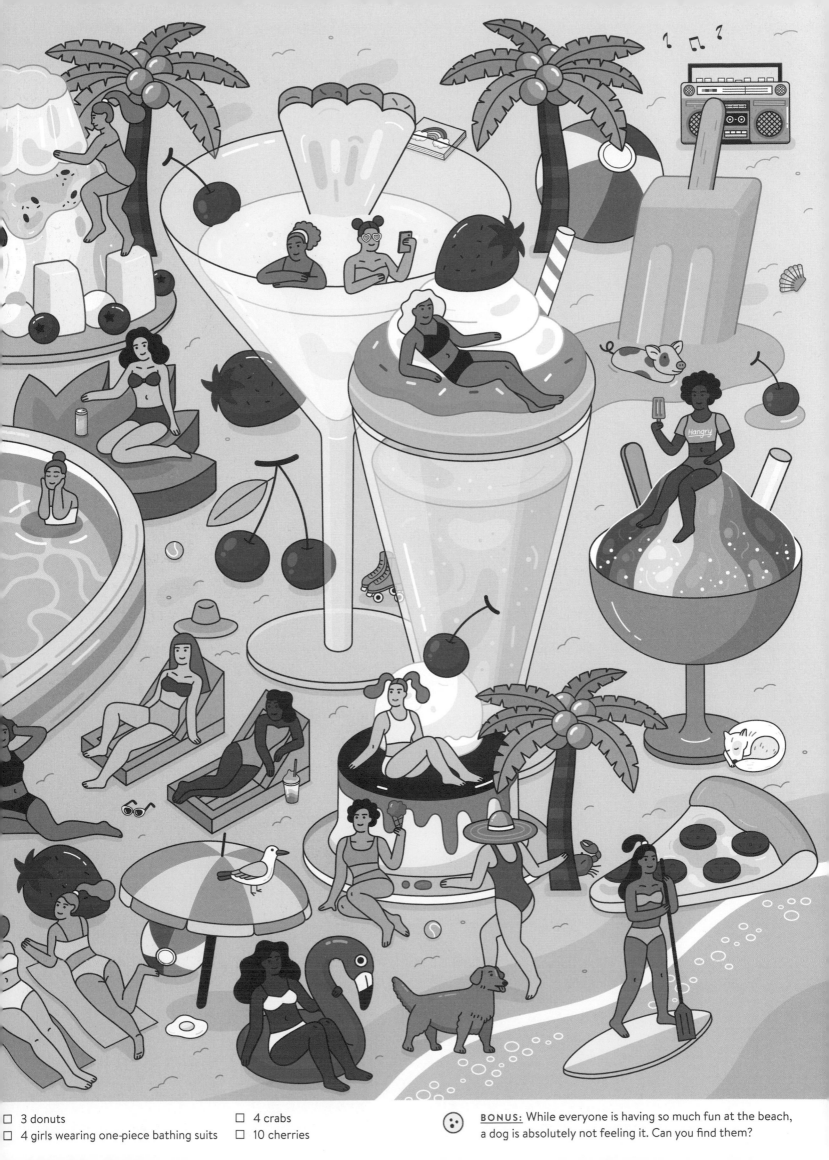

☐ 3 donuts

☐ 4 girls wearing one-piece bathing suits

☐ 4 crabs

☐ 10 cherries

BONUS: While everyone is having so much fun at the beach, a dog is absolutely not feeling it. Can you find them?

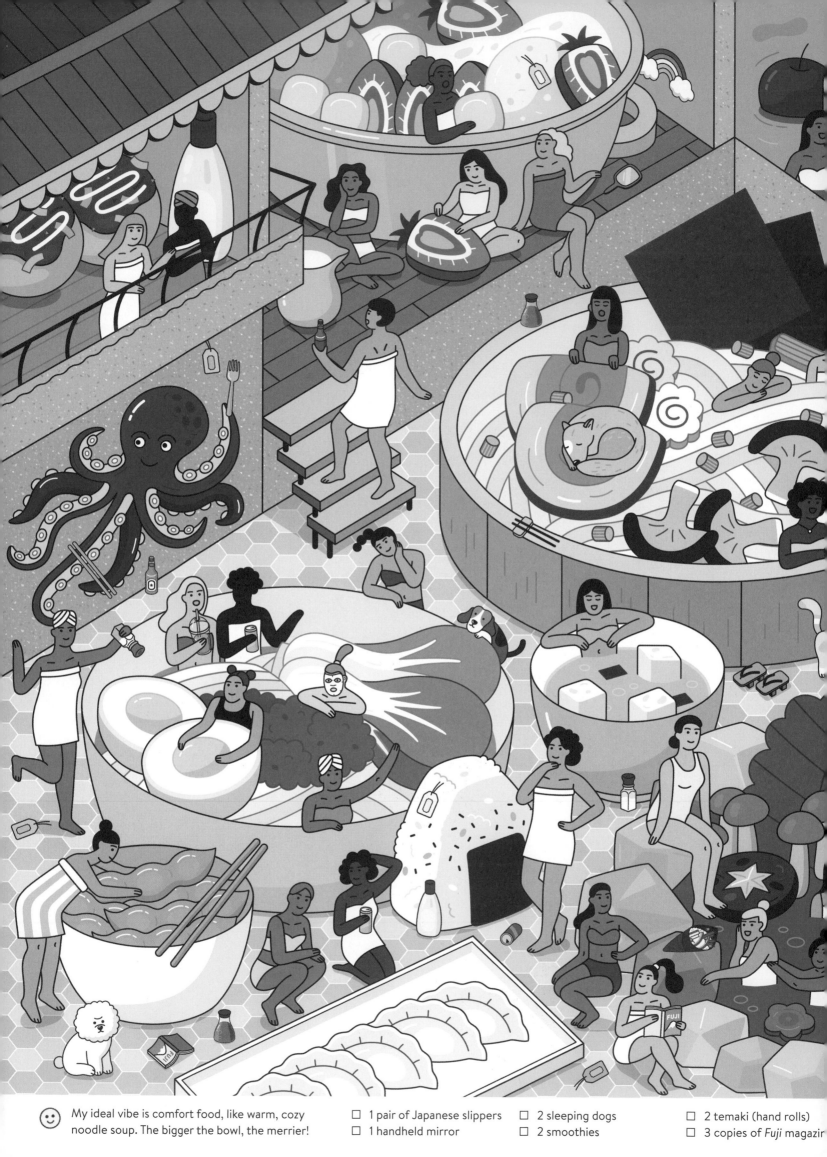

My ideal vibe is comfort food, like warm, cozy noodle soup. The bigger the bowl, the merrier!

- ☐ 1 pair of Japanese slippers
- ☐ 1 handheld mirror
- ☐ 2 sleeping dogs
- ☐ 2 smoothies
- ☐ 2 temaki (hand rolls)
- ☐ 3 copies of *Fuji* magazine

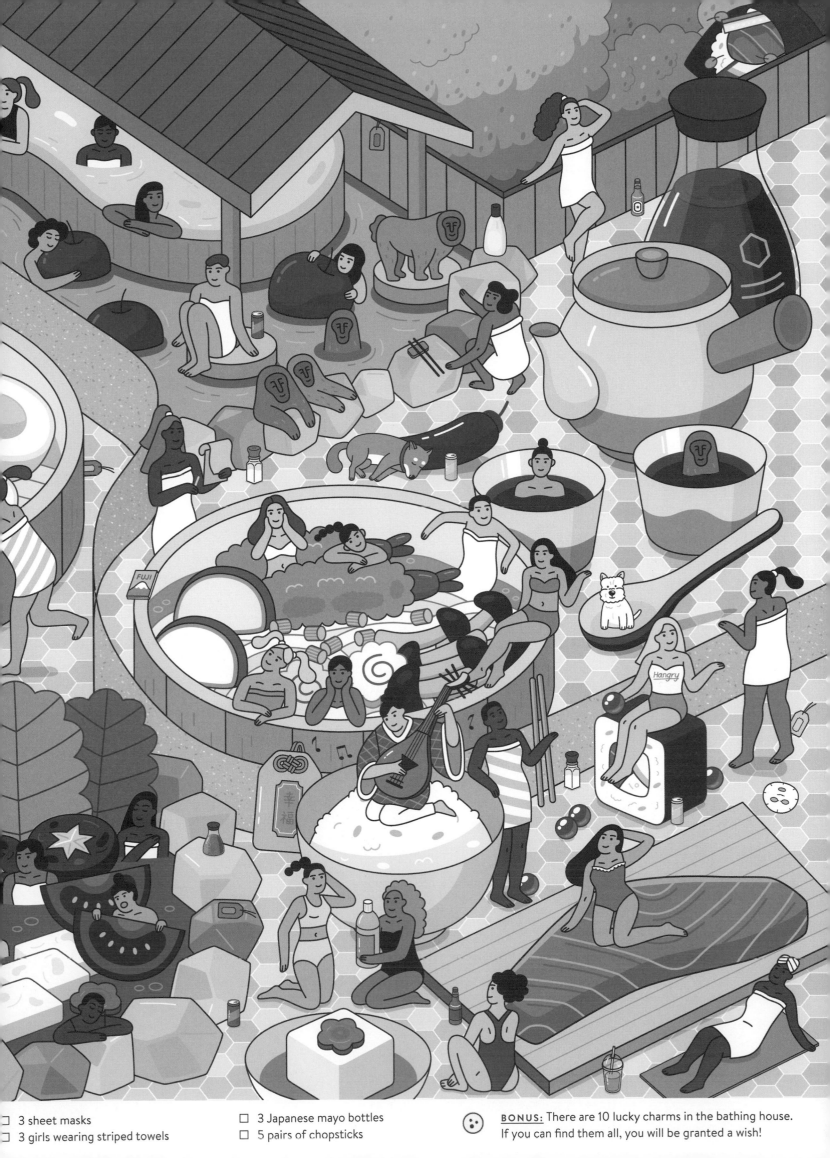

☐ 3 sheet masks

☐ 3 girls wearing striped towels

☐ 3 Japanese mayo bottles

☐ 5 pairs of chopsticks

BONUS: There are 10 lucky charms in the bathing house. If you can find them all, you will be granted a wish!

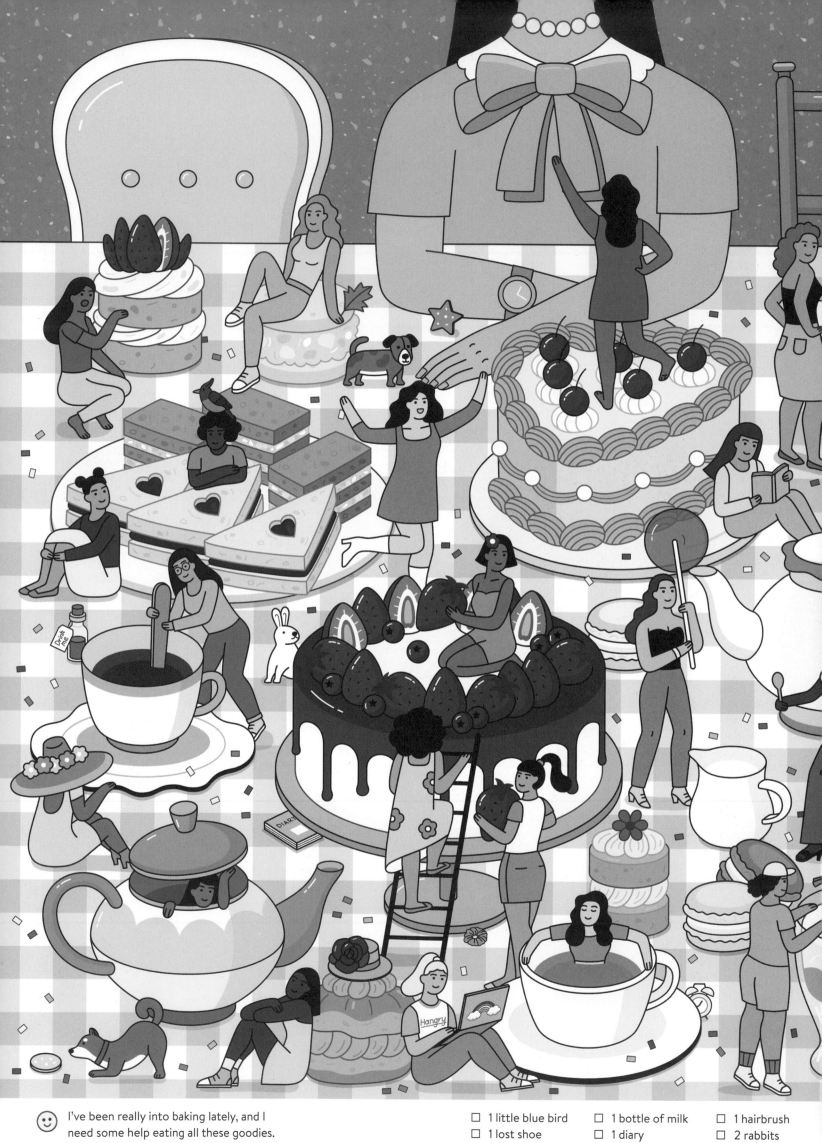

I've been really into baking lately, and I need some help eating all these goodies.

- ☐ 1 little blue bird
- ☐ 1 lost shoe
- ☐ 1 bottle of milk
- ☐ 1 diary
- ☐ 1 hairbrush
- ☐ 2 rabbits

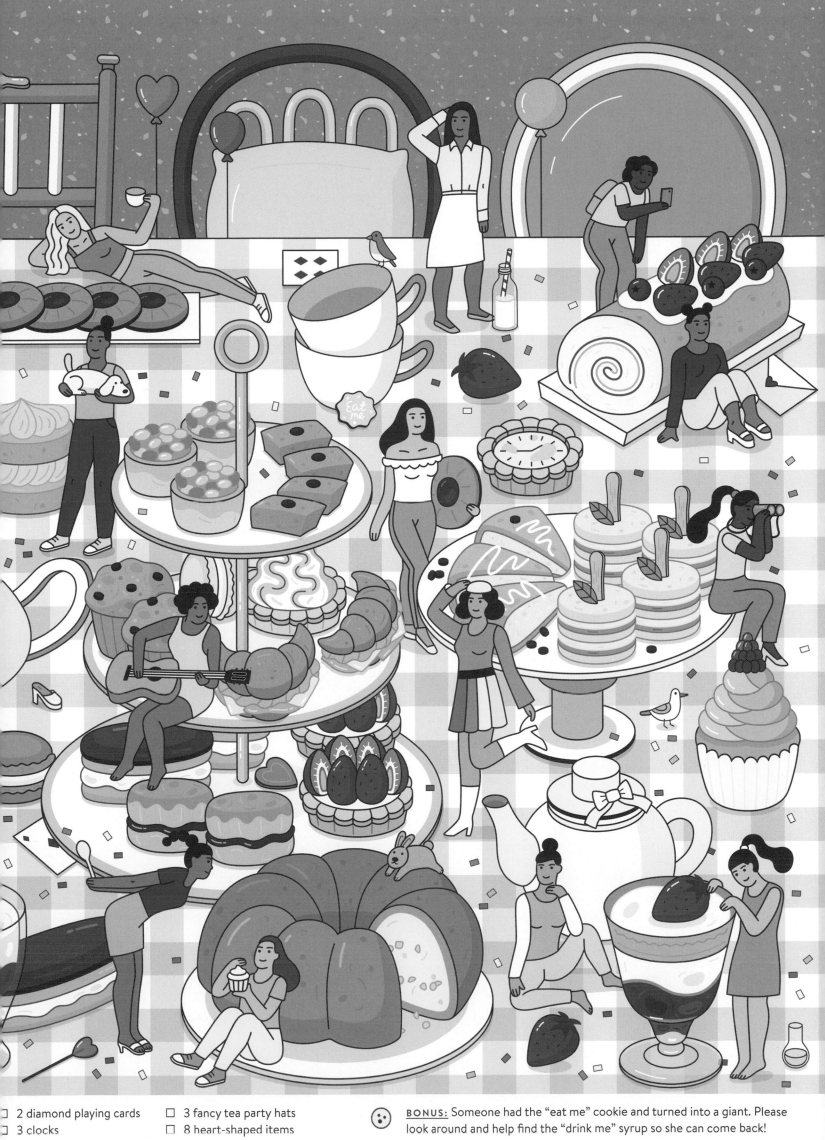

☐ 2 diamond playing cards
☐ 3 clocks
☐ 3 fancy tea party hats
☐ 8 heart-shaped items

BONUS: Someone had the "eat me" cookie and turned into a giant. Please look around and help find the "drink me" syrup so she can come back!

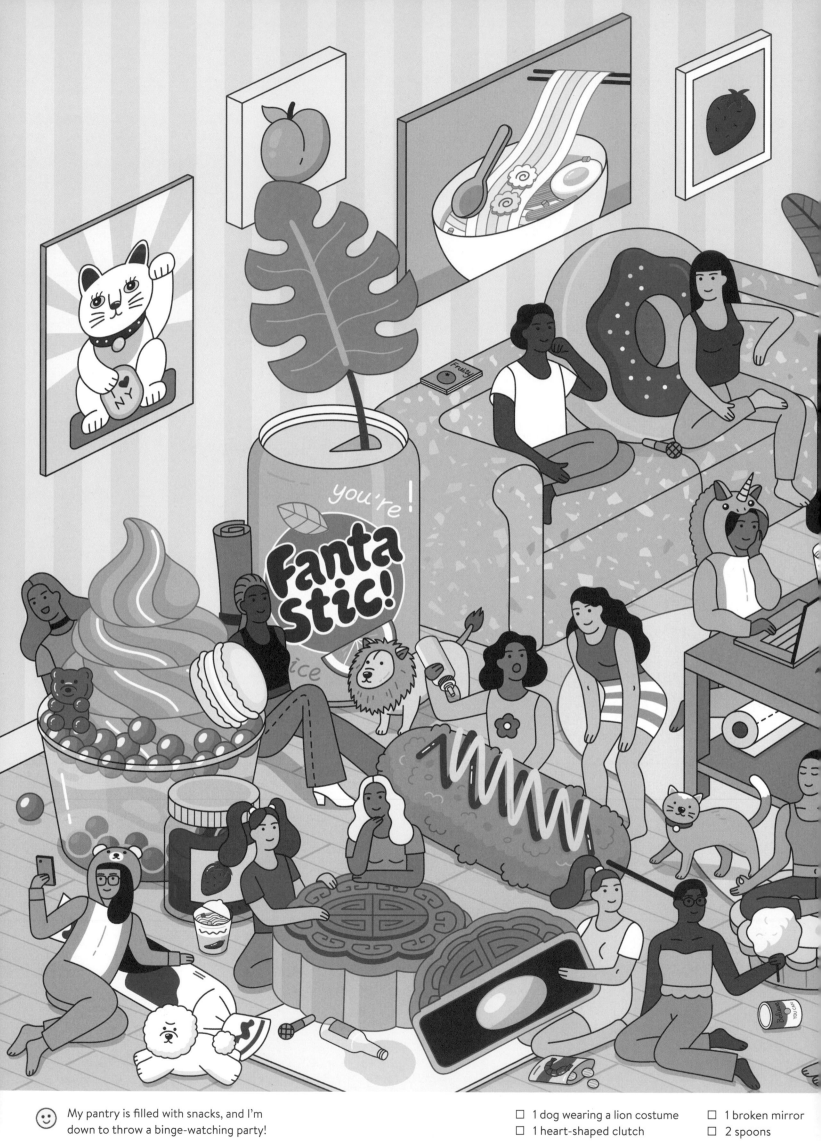

My pantry is filled with snacks, and I'm down to throw a binge-watching party!

☐ 1 dog wearing a lion costume
☐ 1 heart-shaped clutch
☐ 1 broken mirror
☐ 2 spoons

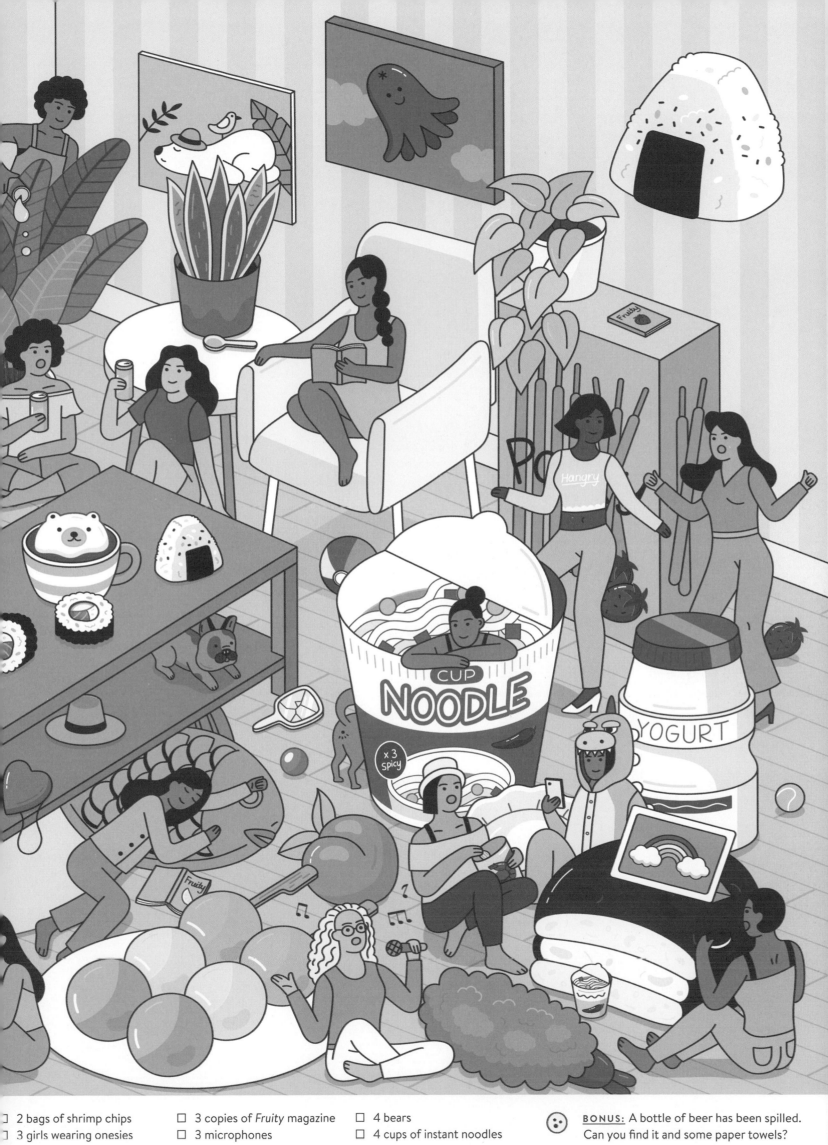

☐ 2 bags of shrimp chips
☐ 3 girls wearing onesies
☐ 3 copies of *Fruity* magazine
☐ 3 microphones
☐ 4 bears
☐ 4 cups of instant noodles

BONUS: A bottle of beer has been spilled. Can you find it and some paper towels?

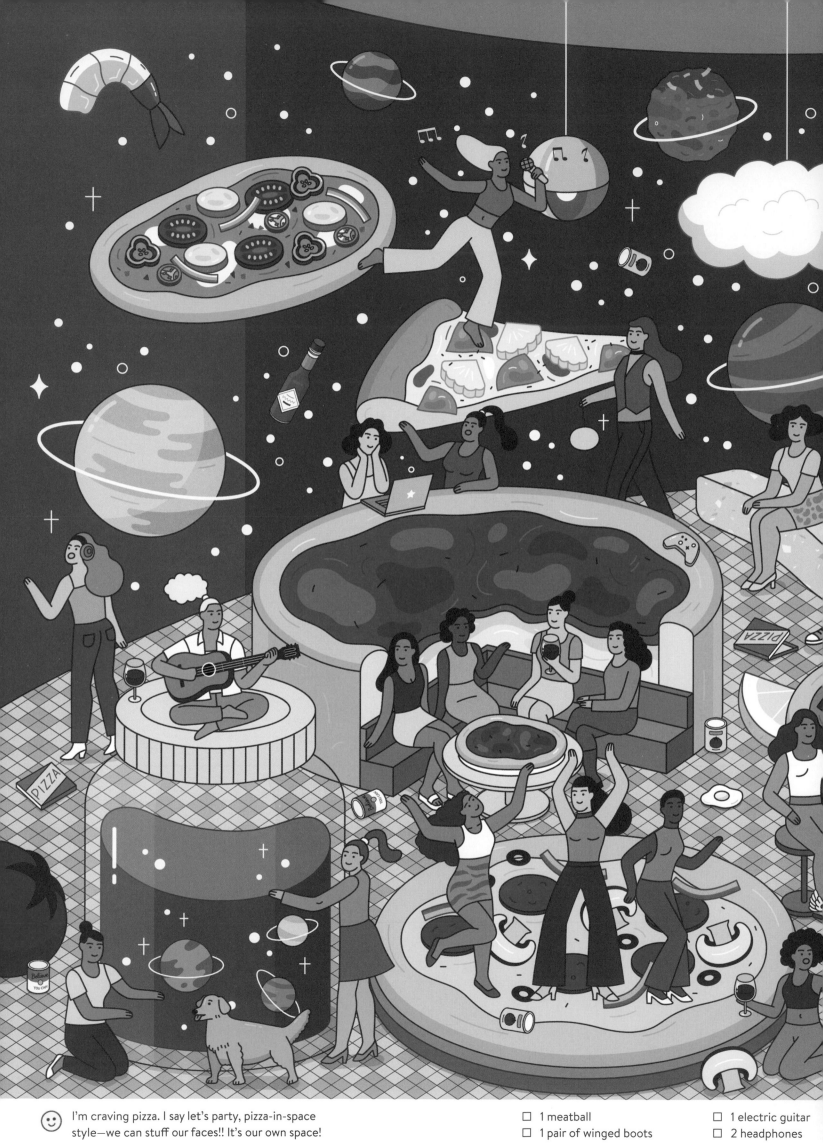

I'm craving pizza. I say let's party, pizza-in-space style—we can stuff our faces!! It's our own space!

- ☐ 1 meatball
- ☐ 1 pair of winged boots
- ☐ 1 electric guitar
- ☐ 2 headphones

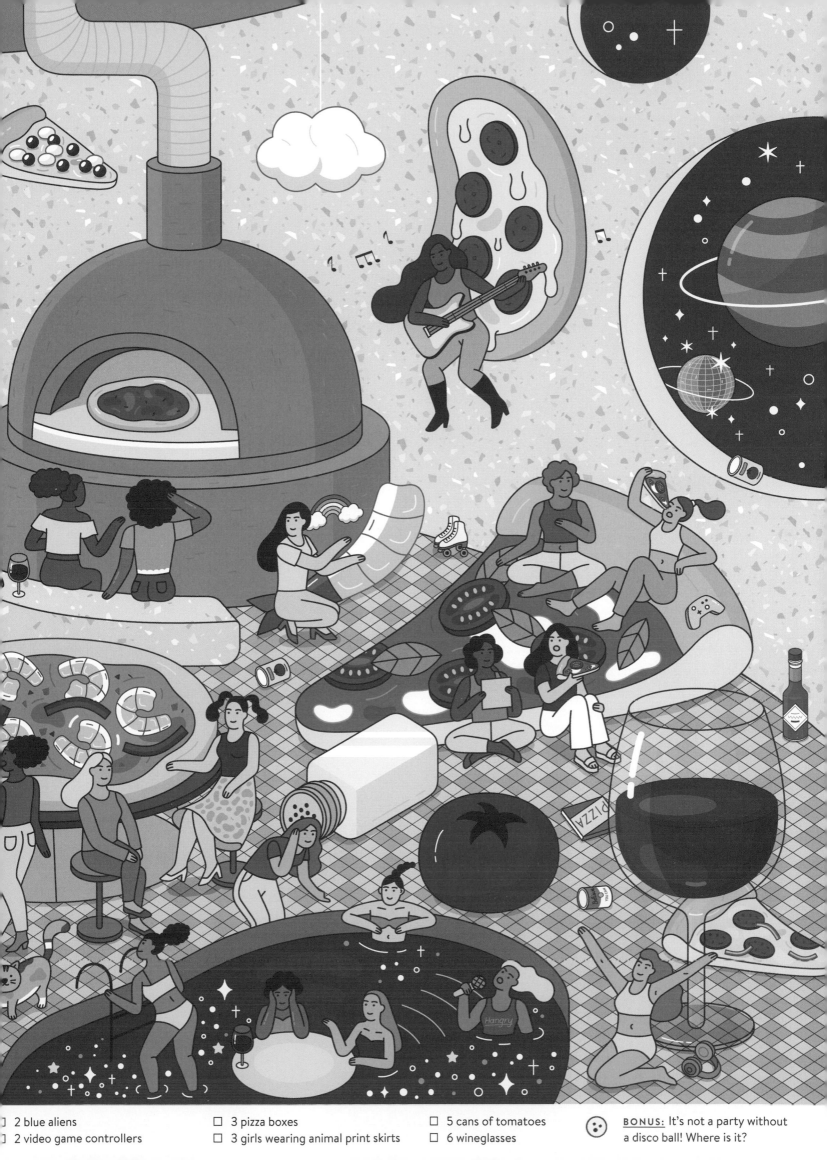

☐ 2 blue aliens
☐ 2 video game controllers
☐ 3 pizza boxes
☐ 3 girls wearing animal print skirts
☐ 5 cans of tomatoes
☐ 6 wineglasses

BONUS: It's not a party without a disco ball! Where is it?

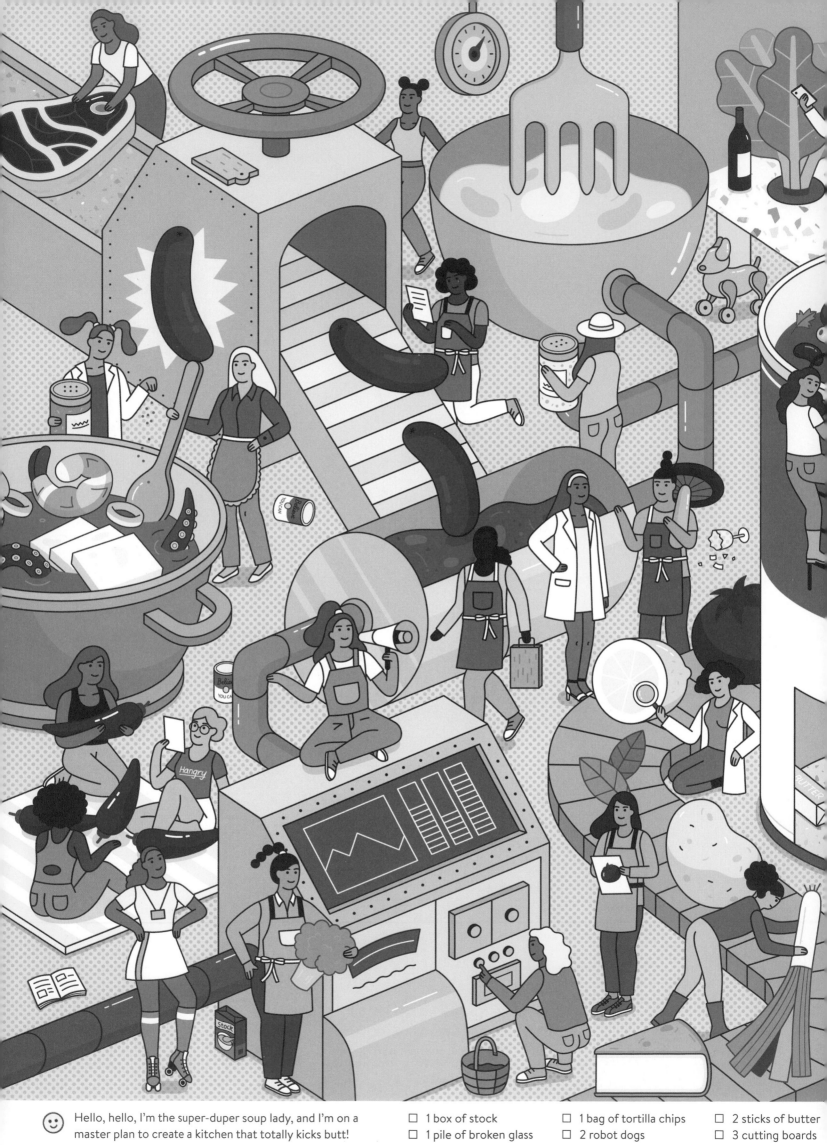

Hello, hello, I'm the super-duper soup lady, and I'm on a master plan to create a kitchen that totally kicks butt!

☐ 1 box of stock
☐ 1 pile of broken glass
☐ 1 bag of tortilla chips
☐ 2 robot dogs
☐ 2 sticks of butter
☐ 3 cutting boards

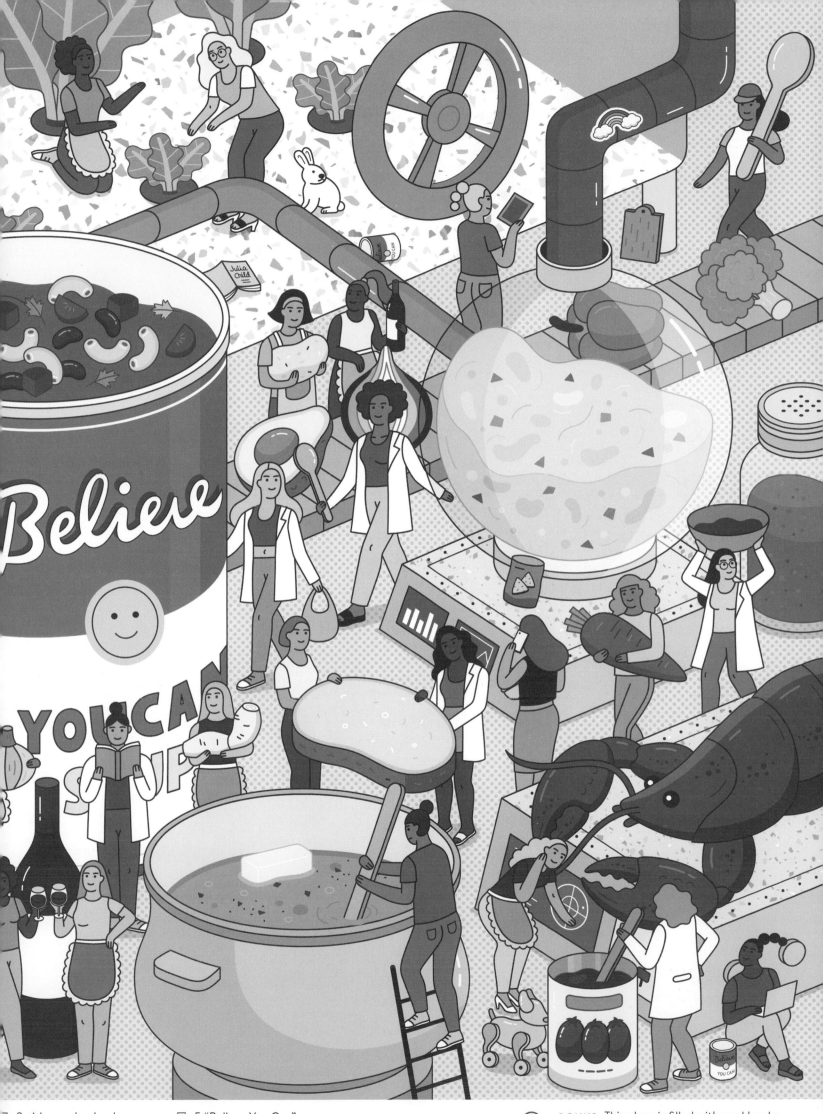

☐ 3 girls wearing heels
☐ 3 bottles of red wine
☐ 5 "Believe You Can" soup cans
☐ 5 whole tomatoes

BONUS: This place is filled with cookbooks— can you help find Julia Child's cookbook?

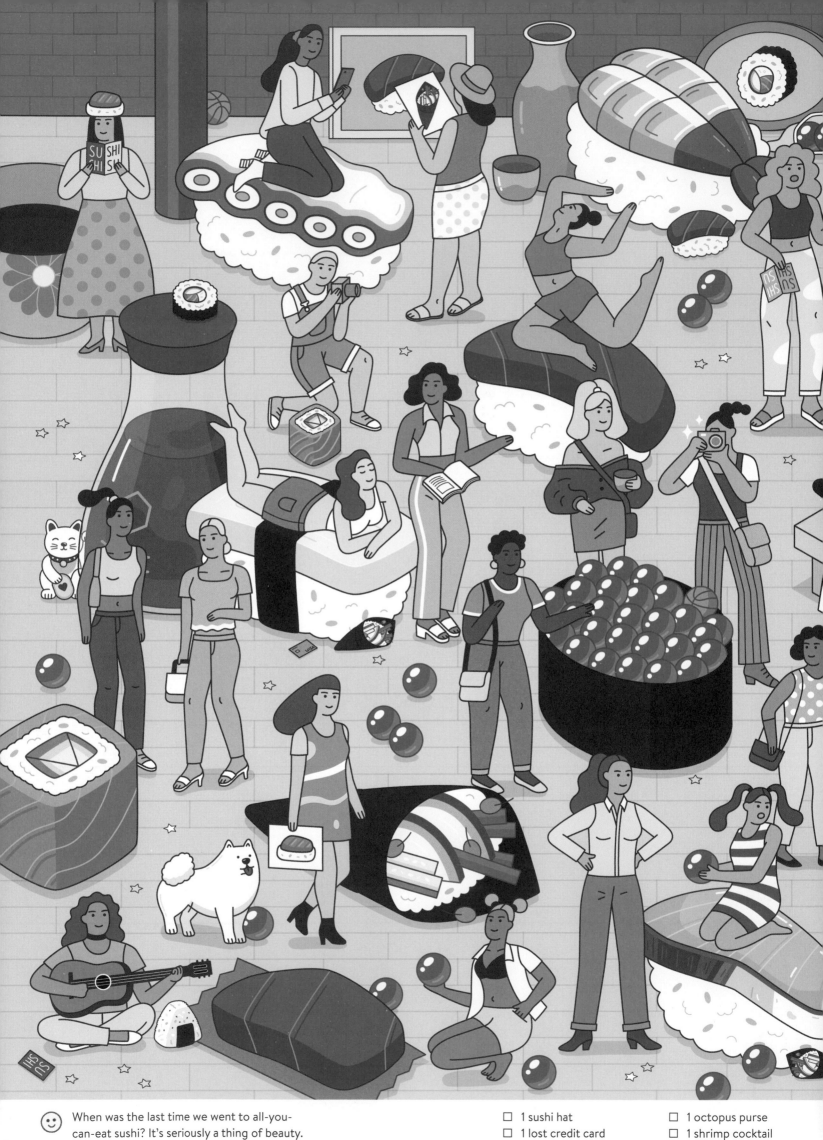

When was the last time we went to all-you-can-eat sushi? It's seriously a thing of beauty.

- ☐ 1 sushi hat
- ☐ 1 lost credit card
- ☐ 1 octopus purse
- ☐ 1 shrimp cocktail

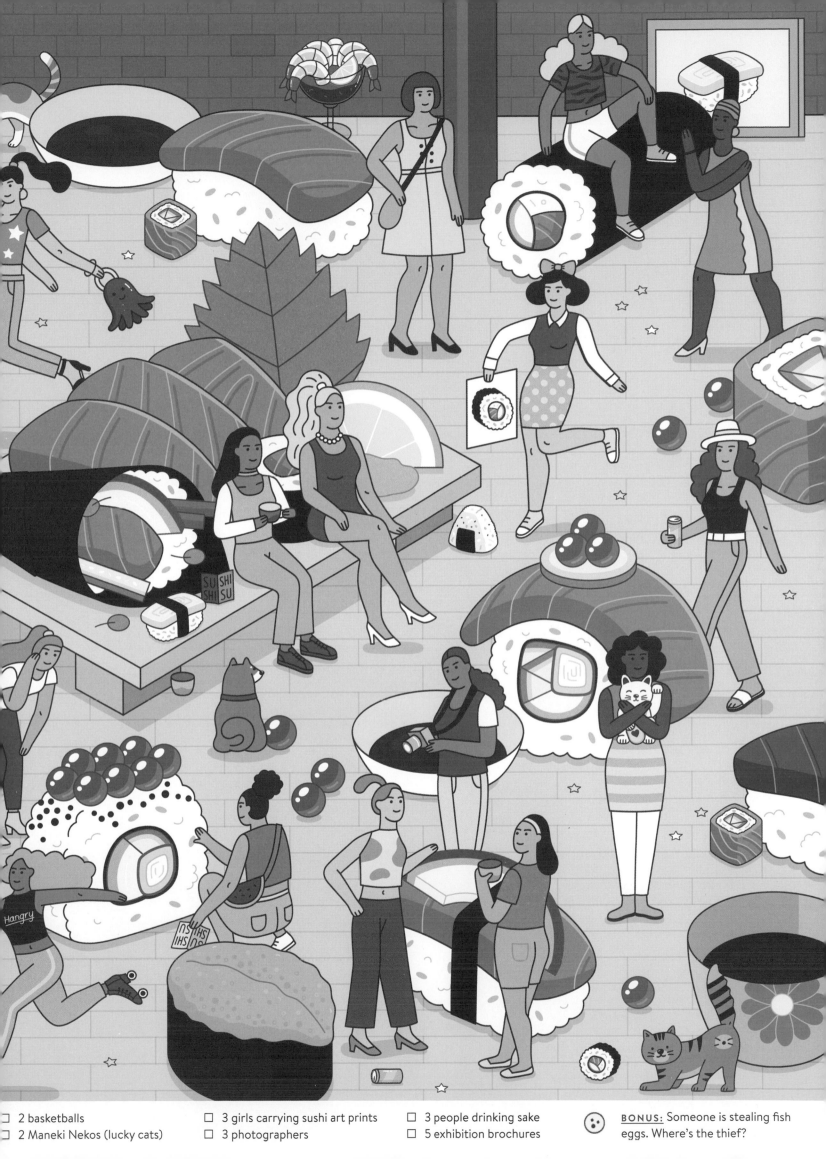

☐ 2 basketballs
☐ 2 Maneki Nekos (lucky cats)
☐ 3 girls carrying sushi art prints
☐ 3 photographers
☐ 3 people drinking sake
☐ 5 exhibition brochures

BONUS: Someone is stealing fish eggs. Where's the thief?

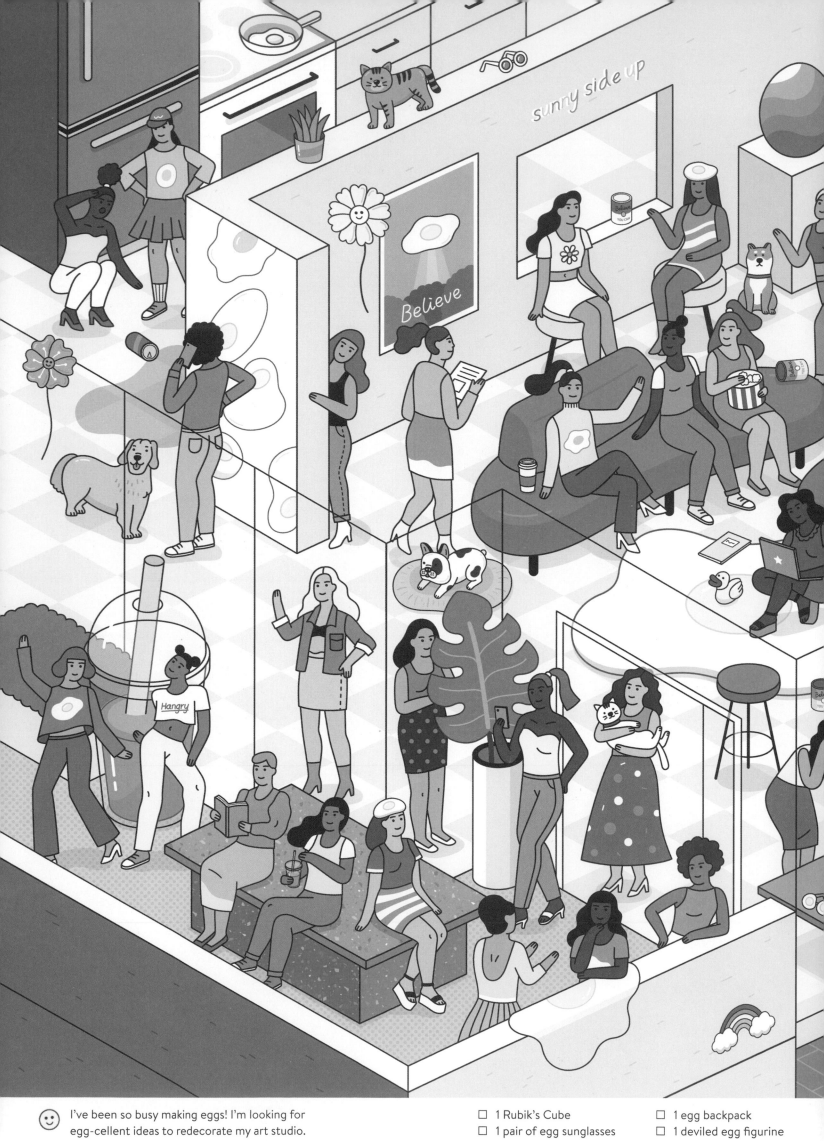

I've been so busy making eggs! I'm looking for egg-cellent ideas to redecorate my art studio.

☐ 1 Rubik's Cube
☐ 1 pair of egg sunglasses

☐ 1 egg backpack
☐ 1 deviled egg figurine

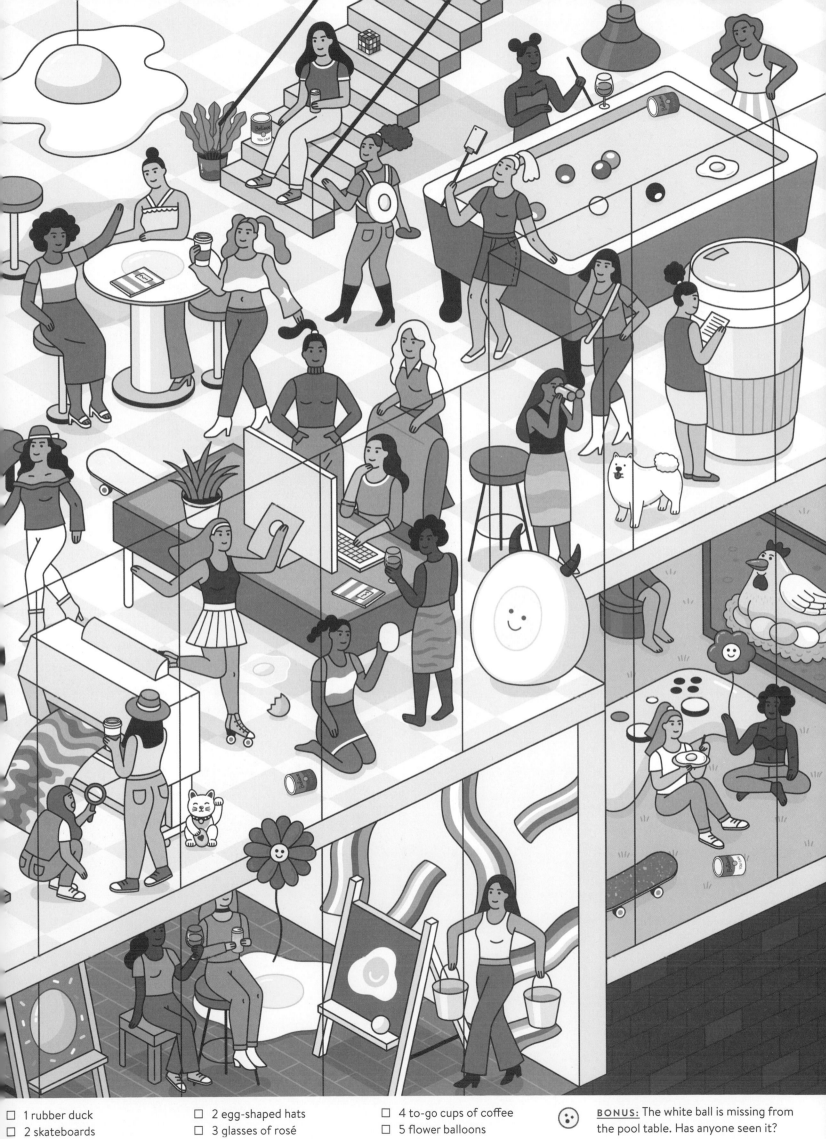

☐ 1 rubber duck
☐ 2 skateboards
☐ 2 egg-shaped hats
☐ 3 glasses of rosé
☐ 4 to-go cups of coffee
☐ 5 flower balloons

BONUS: The white ball is missing from the pool table. Has anyone seen it?

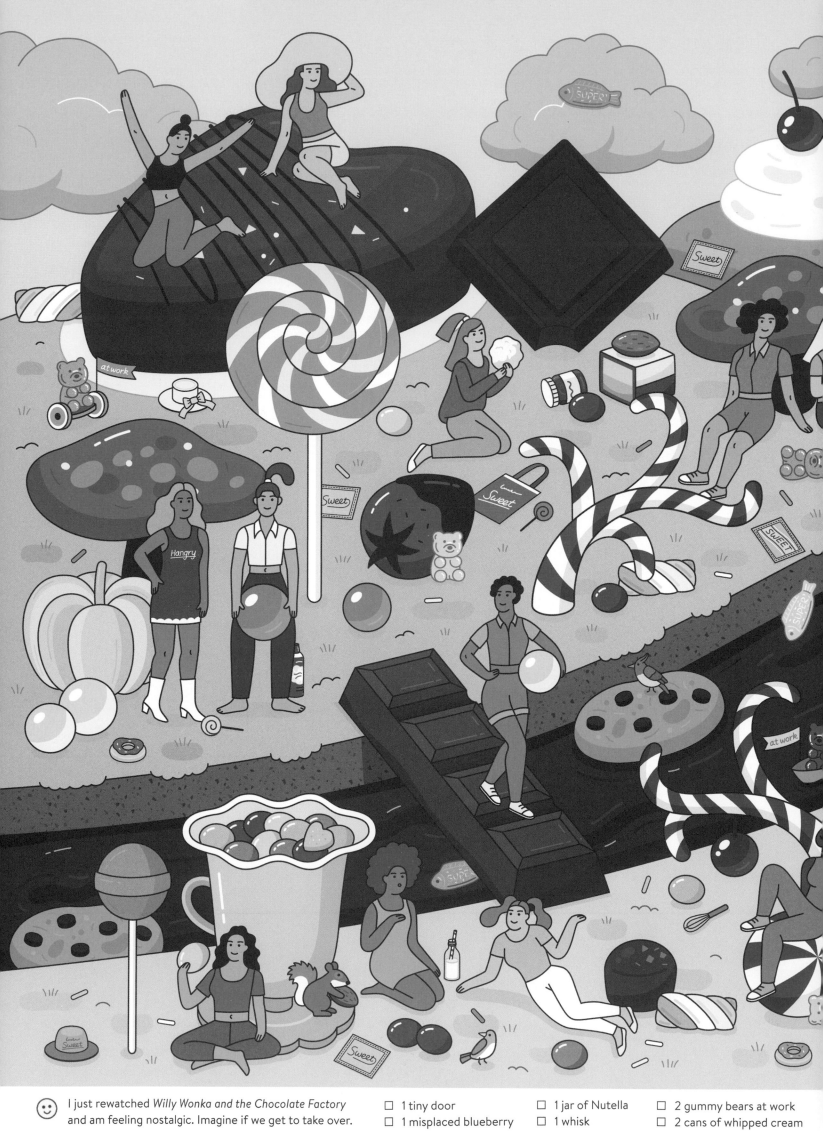

I just rewatched *Willy Wonka and the Chocolate Factory* and am feeling nostalgic. Imagine if we get to take over.

- ☐ 1 tiny door
- ☐ 1 misplaced blueberry
- ☐ 1 jar of Nutella
- ☐ 1 whisk
- ☐ 2 gummy bears at work
- ☐ 2 cans of whipped cream

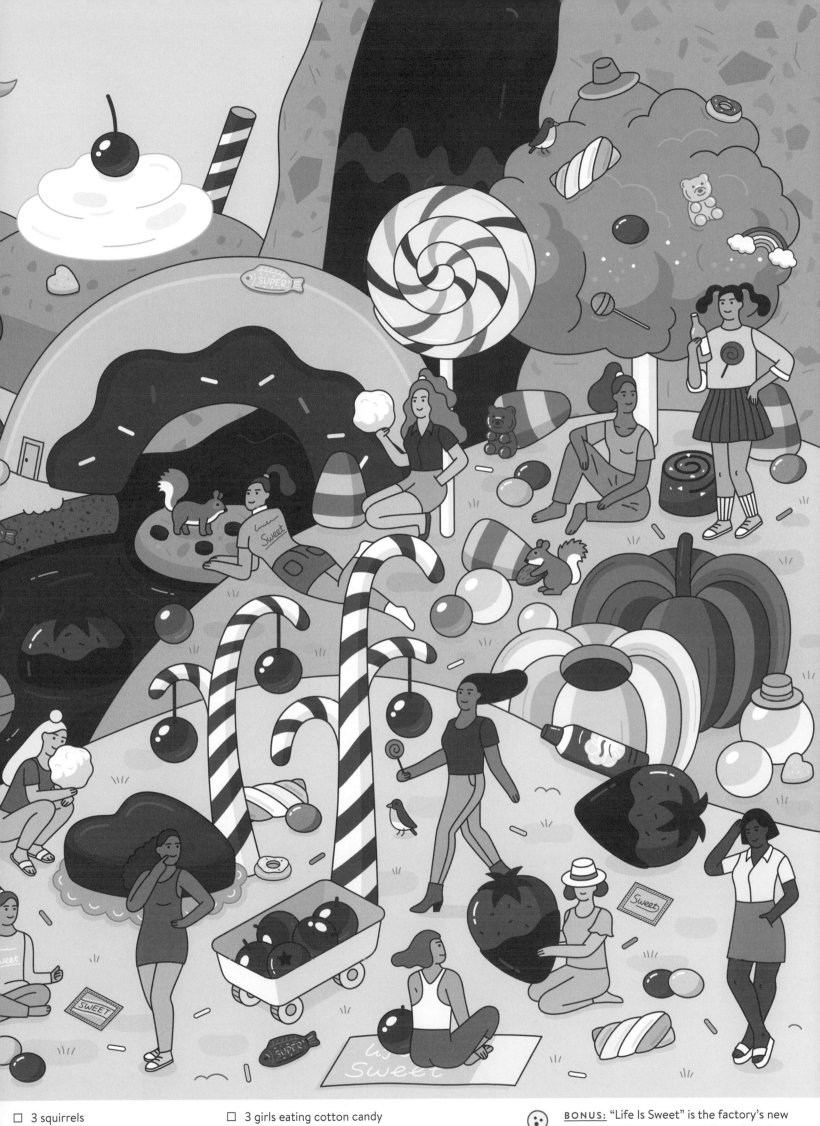

☐ 3 squirrels

☐ 3 heart-shaped sour candies

☐ 3 girls eating cotton candy

☐ 6 fish-shaped gummies

BONUS: "Life Is Sweet" is the factory's new merch line. Can you spot all 5 products?

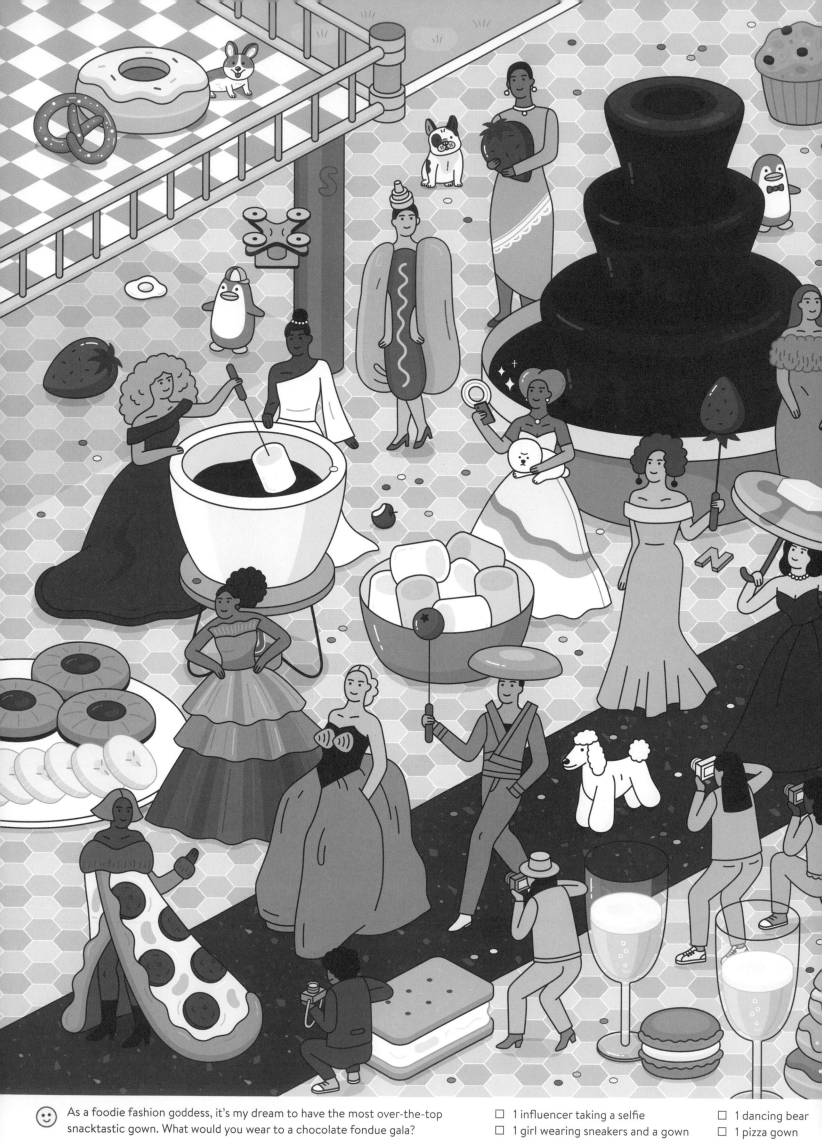

As a foodie fashion goddess, it's my dream to have the most over-the-top snacktastic gown. What would you wear to a chocolate fondue gala?

☐ 1 influencer taking a selfie
☐ 1 girl wearing sneakers and a gown
☐ 1 dancing bear
☐ 1 pizza gown

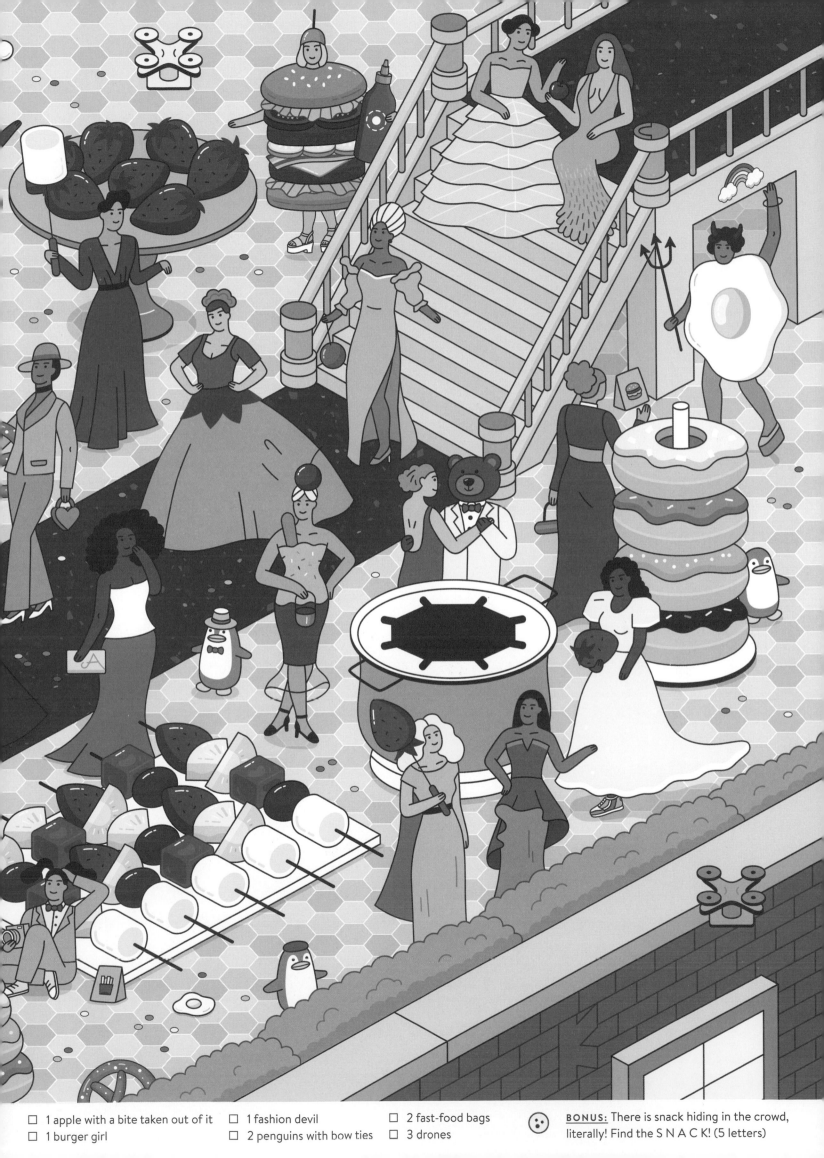

☐ 1 apple with a bite taken out of it ☐ 1 fashion devil ☐ 2 fast-food bags **BONUS:** There is snack hiding in the crowd,
☐ 1 burger girl ☐ 2 penguins with bow ties ☐ 3 drones literally! Find the S N A C K! (5 letters)

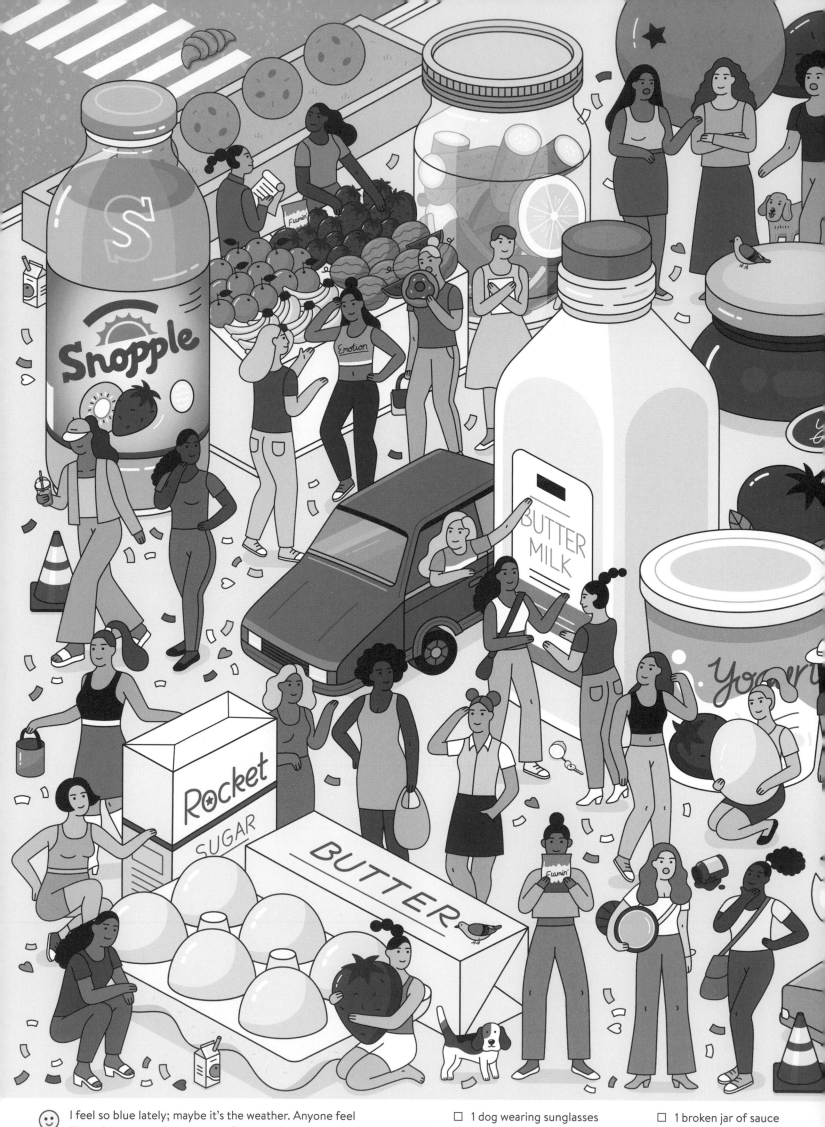

I feel so blue lately; maybe it's the weather. Anyone feel like a drive through the market for some food therapy?

☐ 1 dog wearing sunglasses
☐ 1 girl eating a donut
☐ 1 broken jar of sauce
☐ 1 giant ice-cream cone

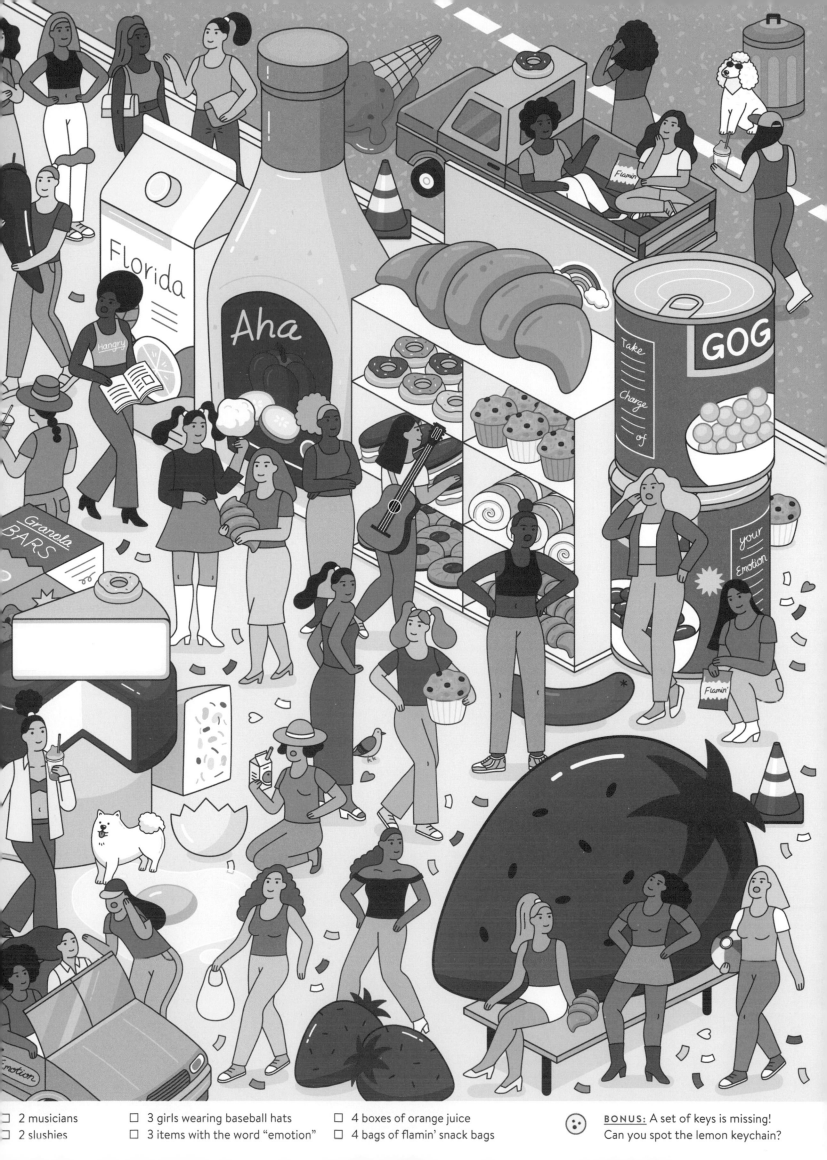

☐ 2 musicians
☐ 2 slushies
☐ 3 girls wearing baseball hats
☐ 3 items with the word "emotion"
☐ 4 boxes of orange juice
☐ 4 bags of flamin' snack bags

BONUS: A set of keys is missing!
Can you spot the lemon keychain?

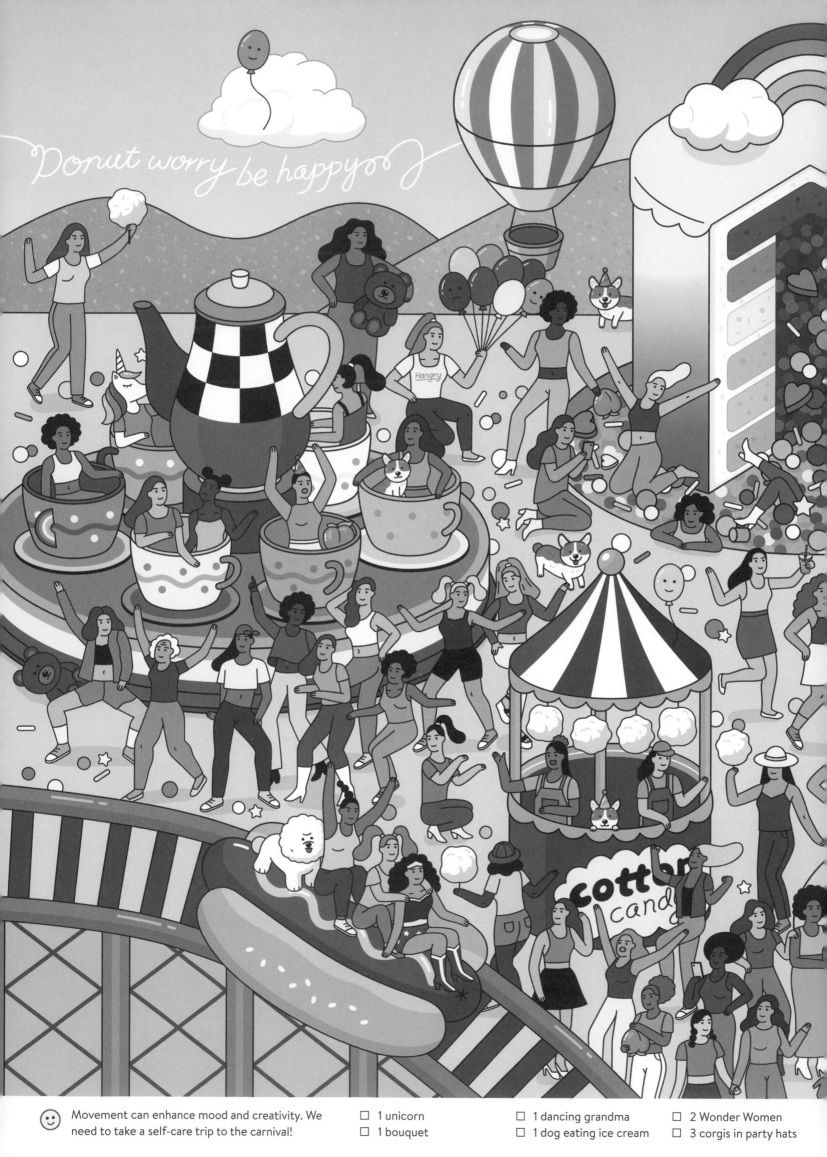

Movement can enhance mood and creativity. We need to take a self-care trip to the carnival!

- ☐ 1 unicorn
- ☐ 1 bouquet
- ☐ 1 dancing grandma
- ☐ 1 dog eating ice cream
- ☐ 2 Wonder Women
- ☐ 3 corgis in party hats

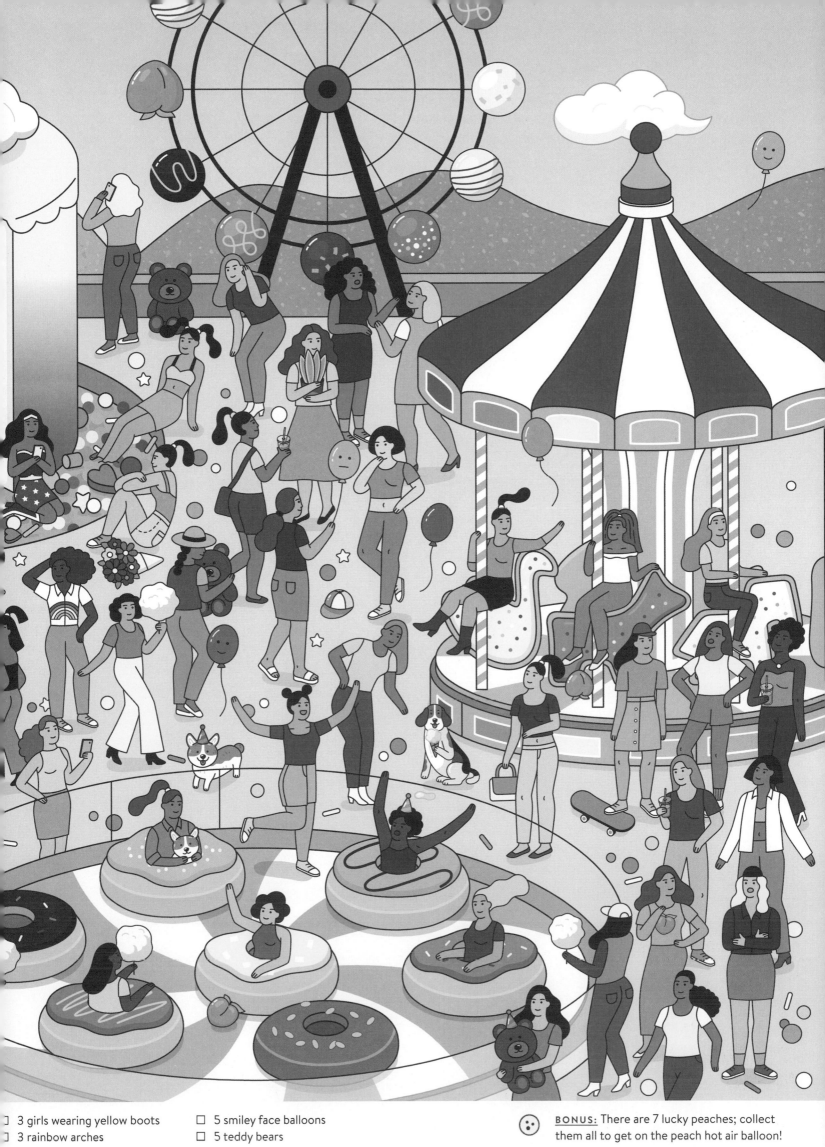

☐ 3 girls wearing yellow boots
☐ 3 rainbow arches
☐ 5 smiley face balloons
☐ 5 teddy bears

BONUS: There are 7 lucky peaches; collect them all to get on the peach hot air balloon!

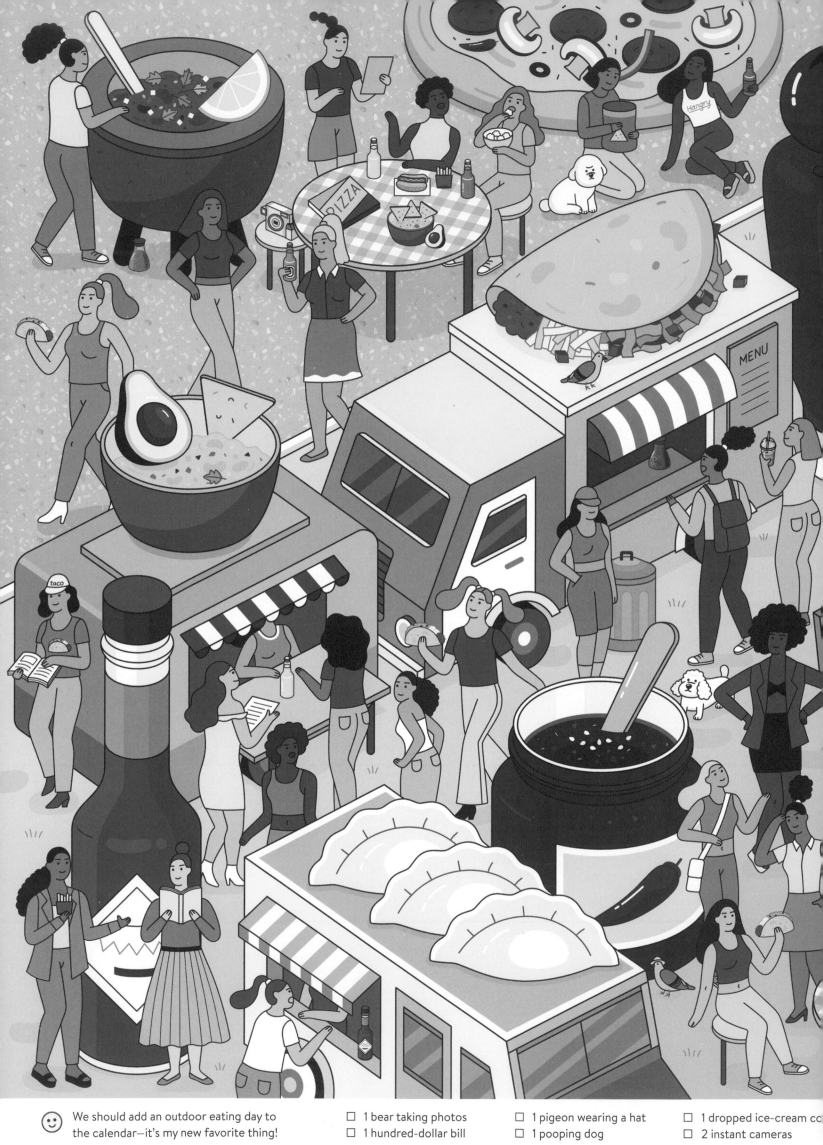

We should add an outdoor eating day to the calendar—it's my new favorite thing!

- ☐ 1 bear taking photos
- ☐ 1 hundred-dollar bill
- ☐ 1 pigeon wearing a hat
- ☐ 1 pooping dog
- ☐ 1 dropped ice-cream co
- ☐ 2 instant cameras

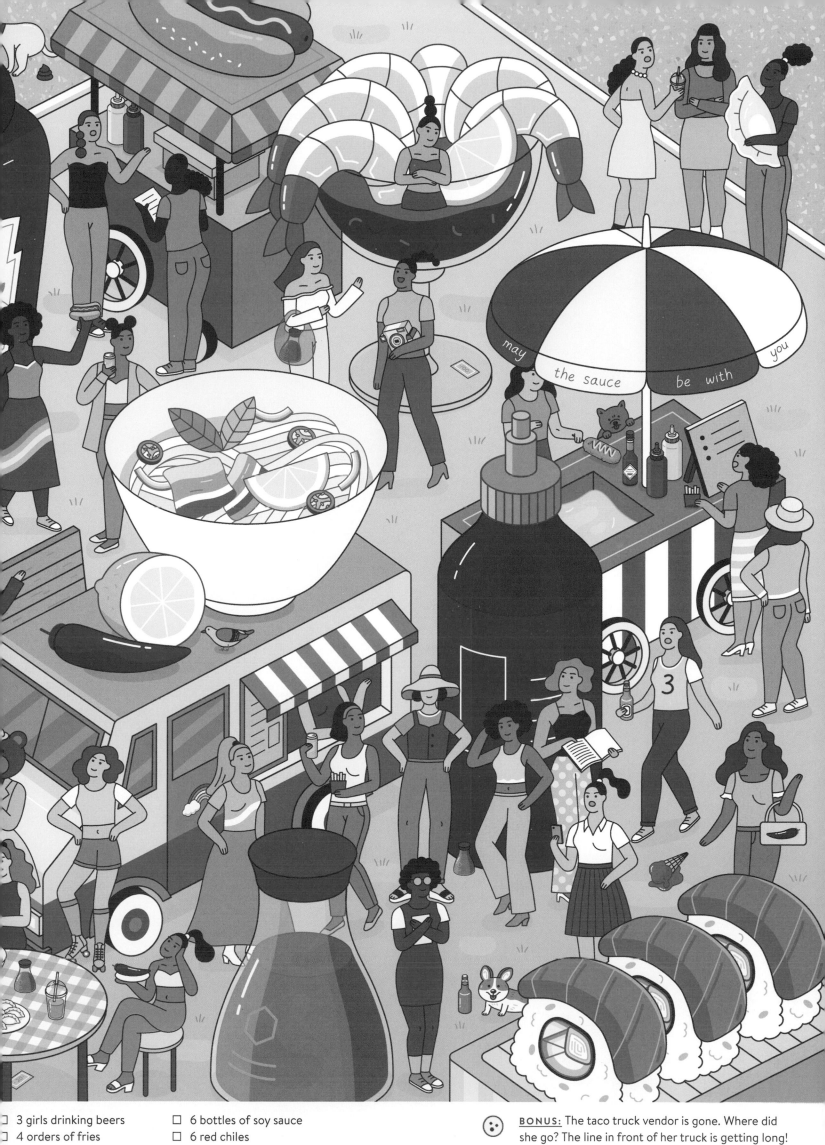

☐ 3 girls drinking beers
☐ 4 orders of fries

☐ 6 bottles of soy sauce
☐ 6 red chiles

BONUS: The taco truck vendor is gone. Where did she go? The line in front of her truck is getting long!

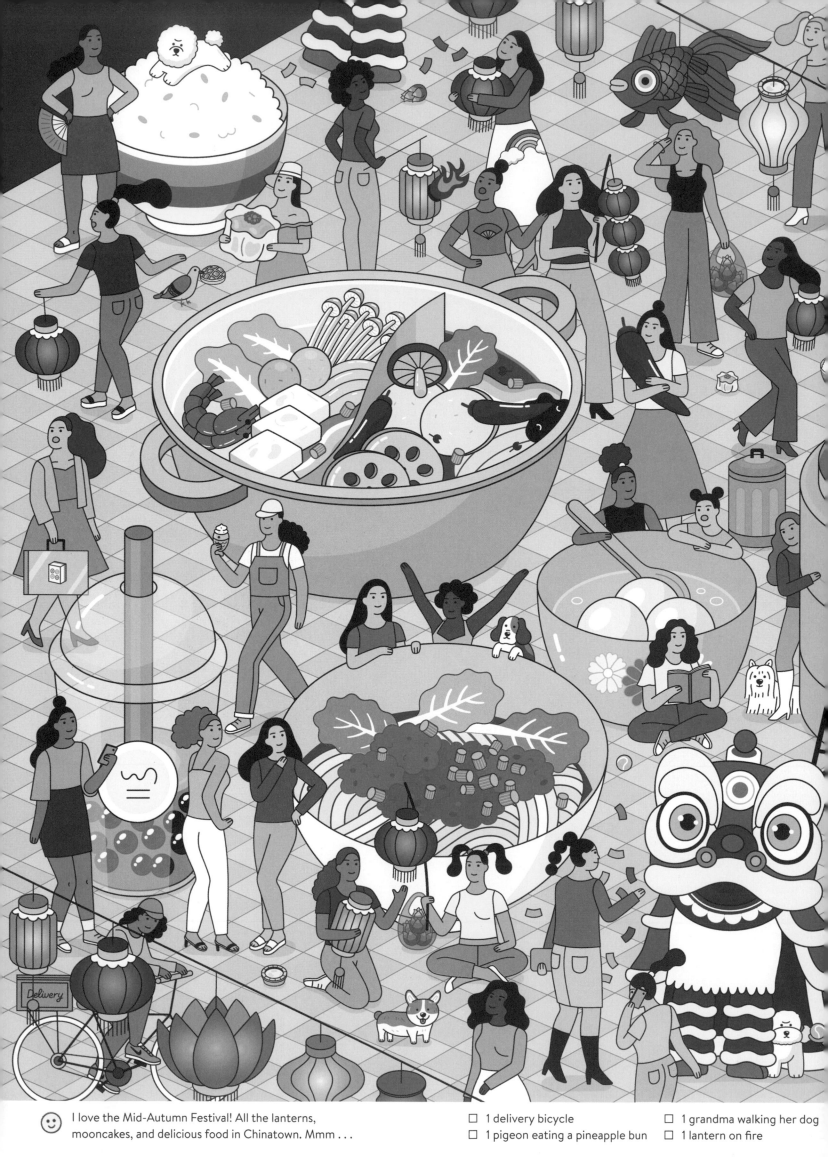

I love the Mid-Autumn Festival! All the lanterns, mooncakes, and delicious food in Chinatown. Mmm . . .

- ☐ 1 delivery bicycle
- ☐ 1 pigeon eating a pineapple bun
- ☐ 1 grandma walking her dog
- ☐ 1 lantern on fire

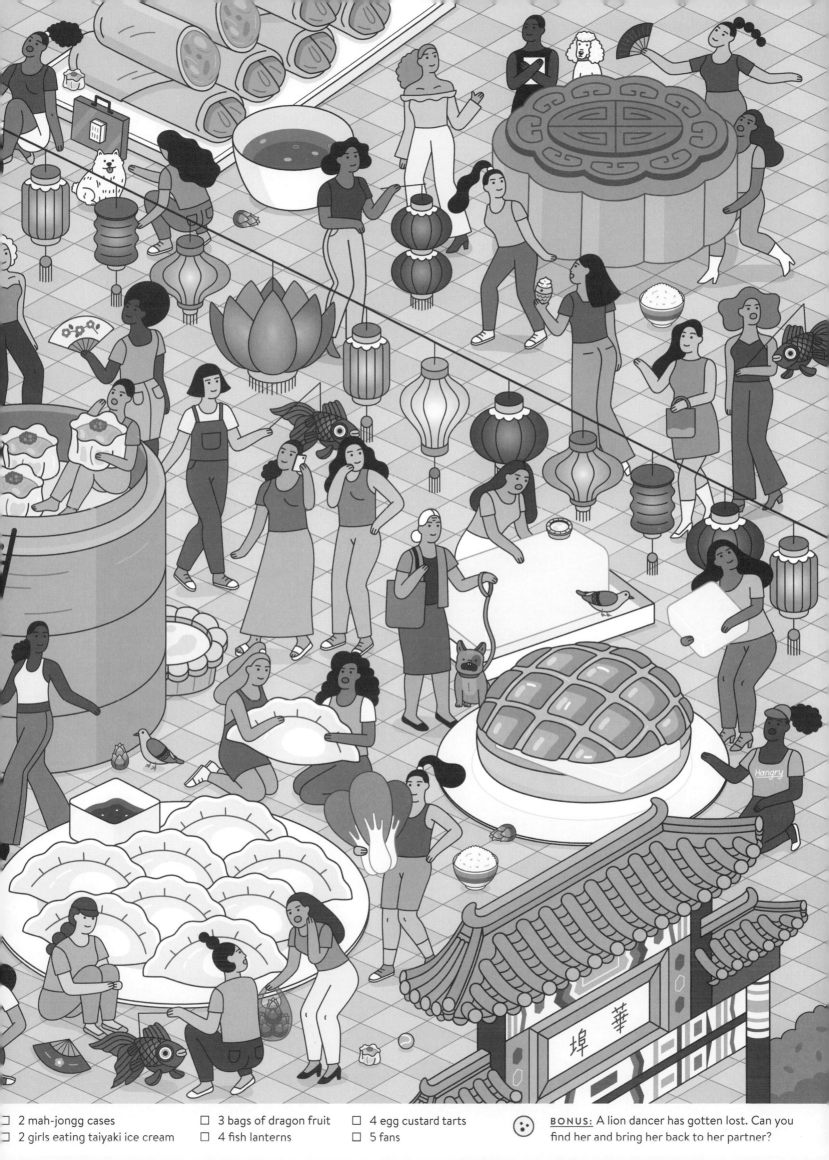

☐ 2 mah-jongg cases
☐ 2 girls eating taiyaki ice cream
☐ 3 bags of dragon fruit
☐ 4 fish lanterns
☐ 4 egg custard tarts
☐ 5 fans

BONUS: A lion dancer has gotten lost. Can you find her and bring her back to her partner?

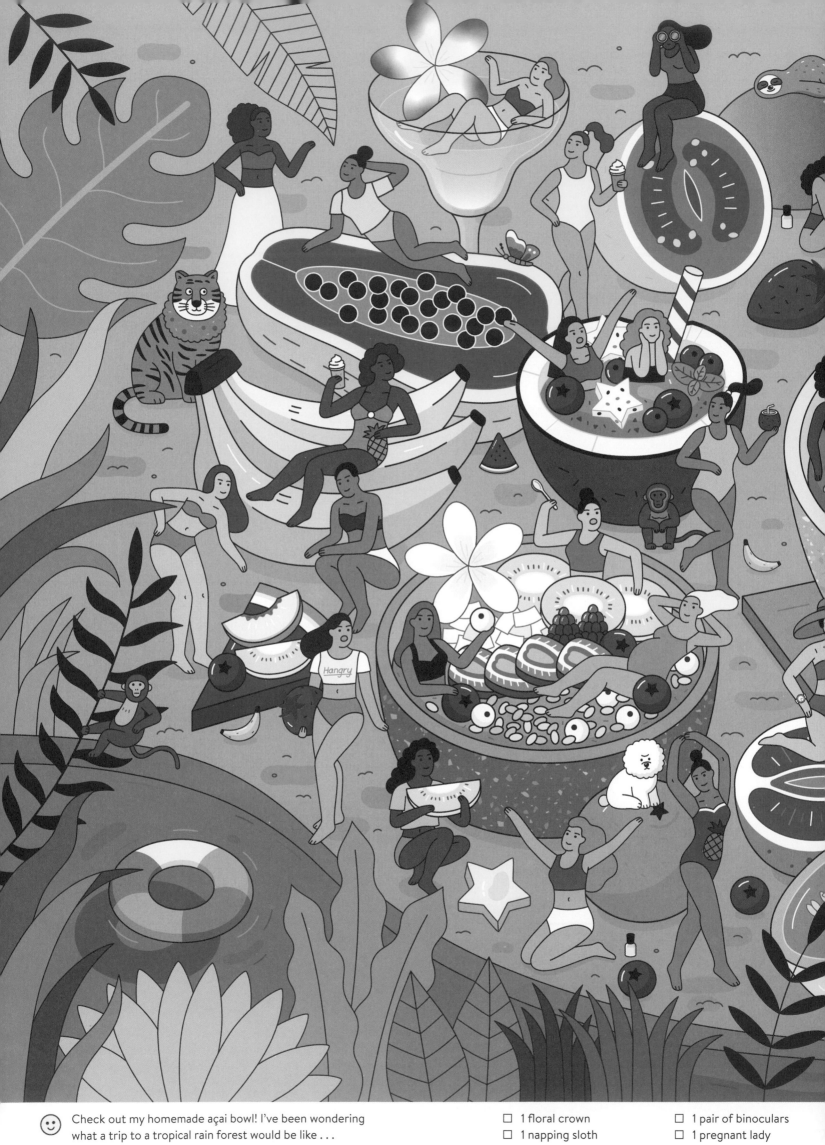

Check out my homemade açai bowl! I've been wondering
what a trip to a tropical rain forest would be like . . .

☐ 1 floral crown
☐ 1 napping sloth

☐ 1 pair of binoculars
☐ 1 pregnant lady

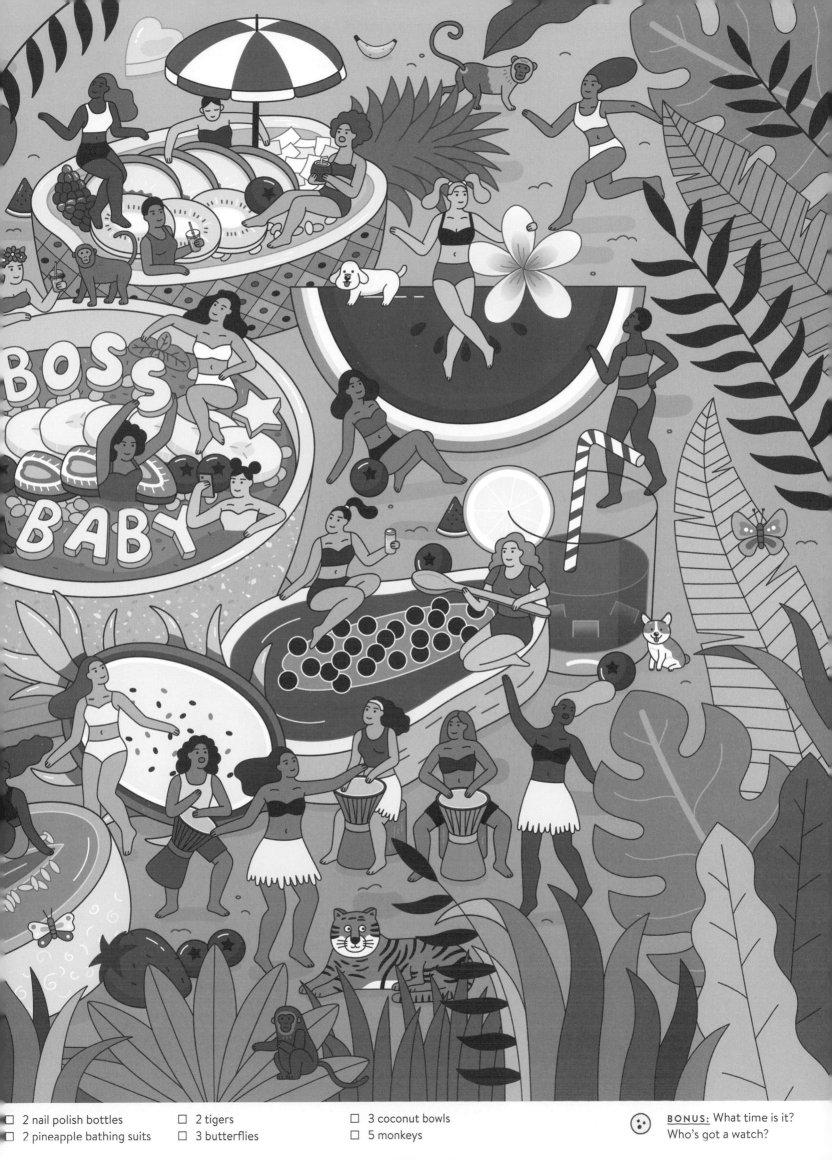

☐ 2 nail polish bottles
☐ 2 pineapple bathing suits
☐ 2 tigers
☐ 3 butterflies
☐ 3 coconut bowls
☐ 5 monkeys

BONUS: What time is it?
Who's got a watch?

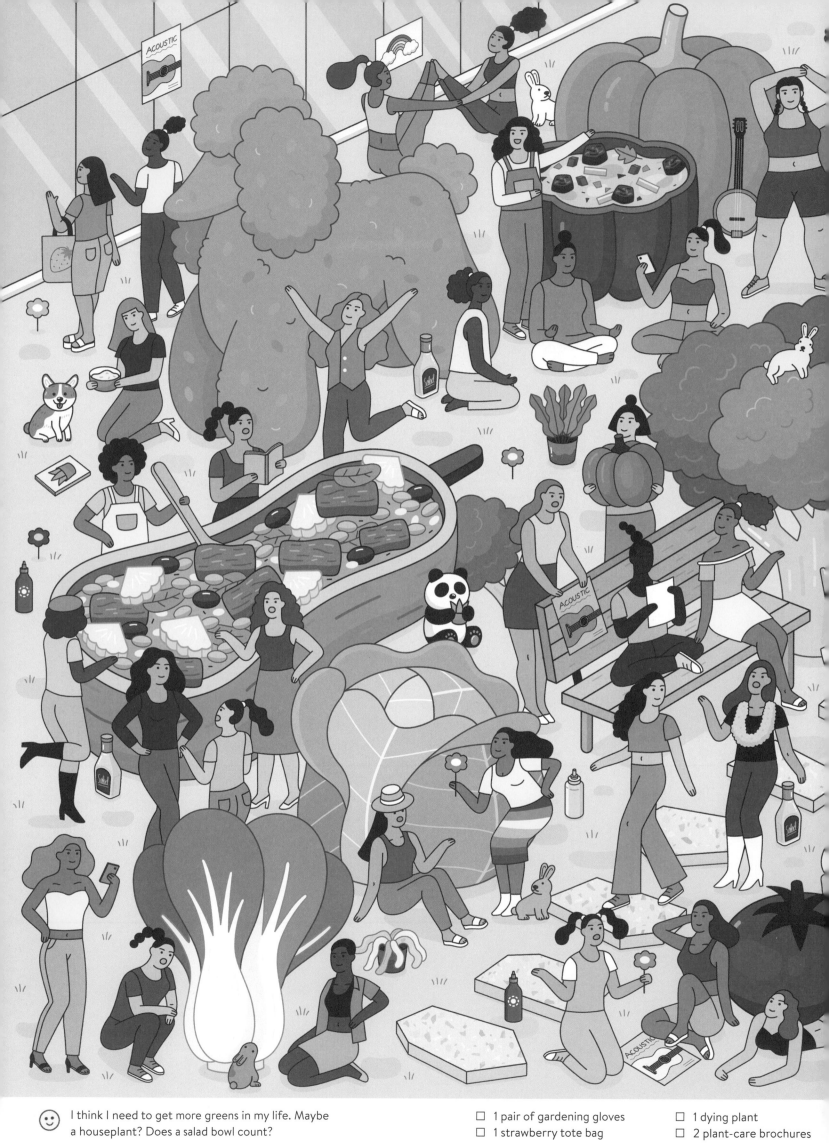

I think I need to get more greens in my life. Maybe a houseplant? Does a salad bowl count?

- ☐ 1 pair of gardening gloves
- ☐ 1 strawberry tote bag
- ☐ 1 dying plant
- ☐ 2 plant-care brochures

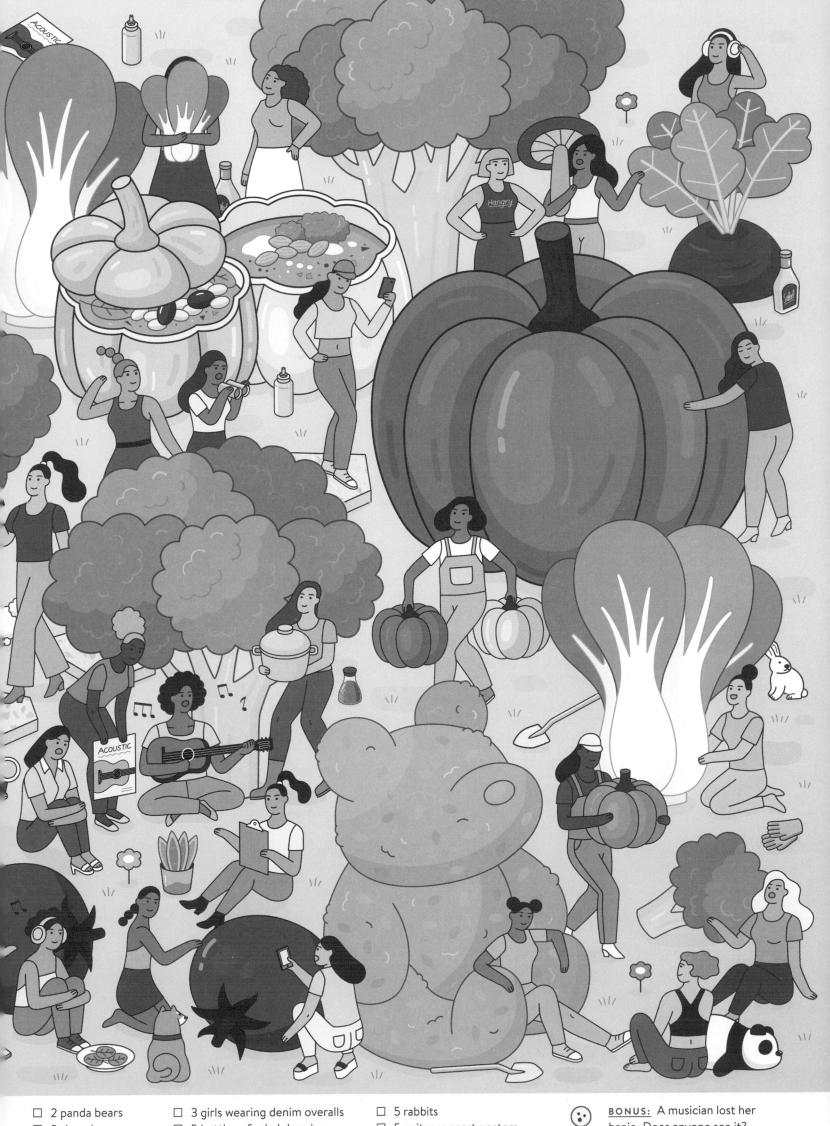

☐ 2 panda bears
☐ 3 shovels
☐ 3 girls wearing denim overalls
☐ 5 bottles of salad dressing
☐ 5 rabbits
☐ 5 guitar concert posters

BONUS: A musician lost her banjo. Does anyone see it?

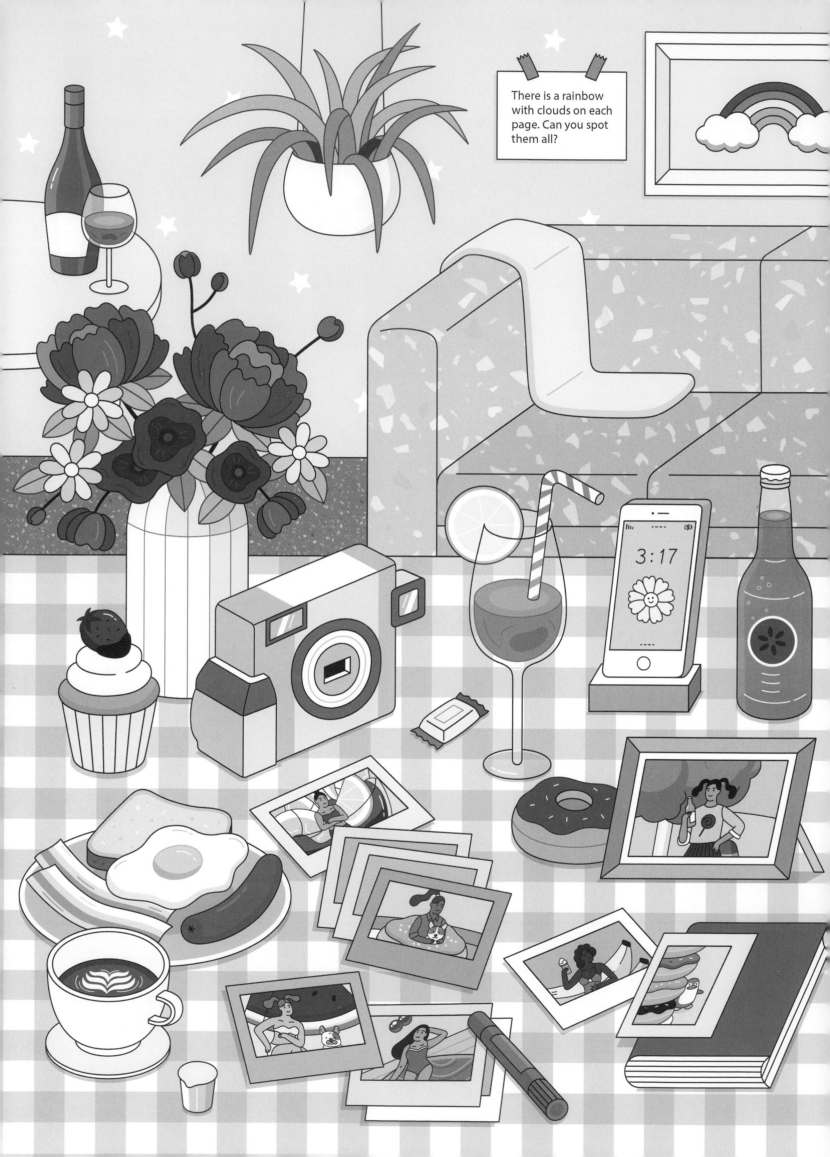

There is a rainbow with clouds on each page. Can you spot them all?

Thank you for coming!

Shrimply Awesome
to the hangry girl club

Friends,

That was so much fun! Let's totally find more time
for some foodie adventures!

XO!

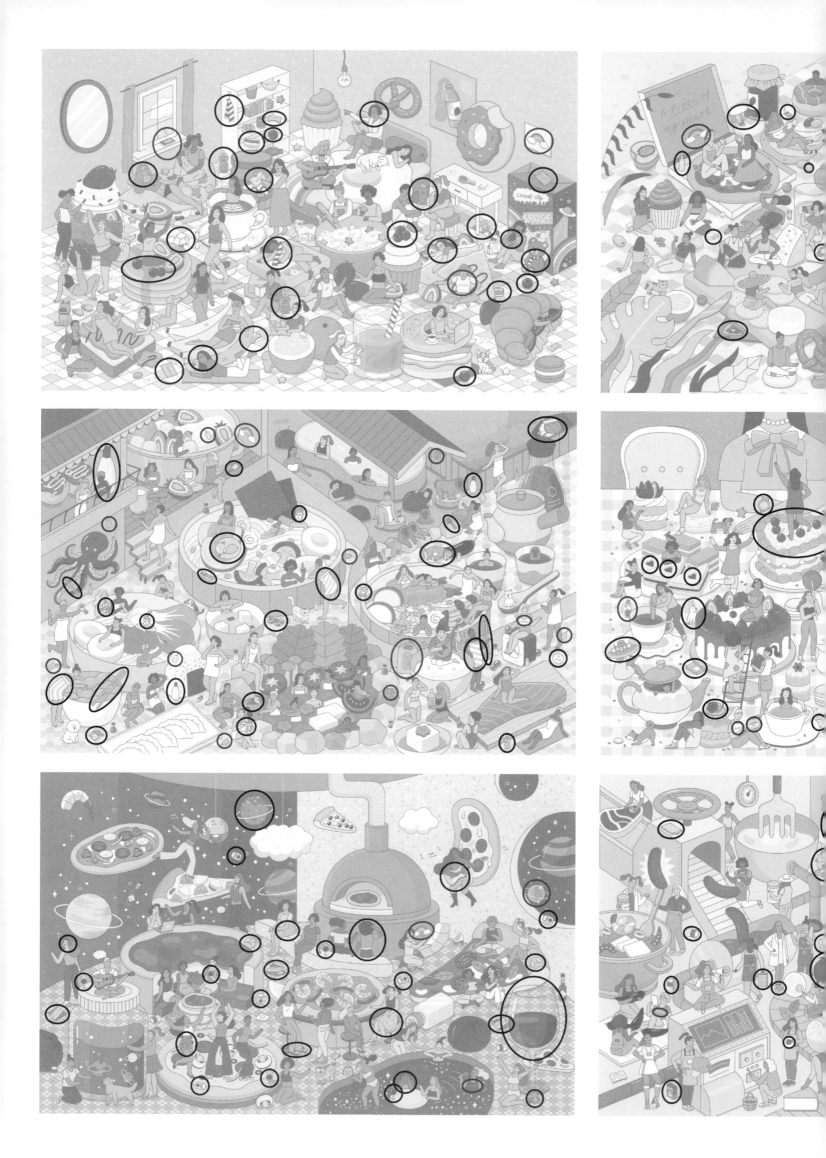

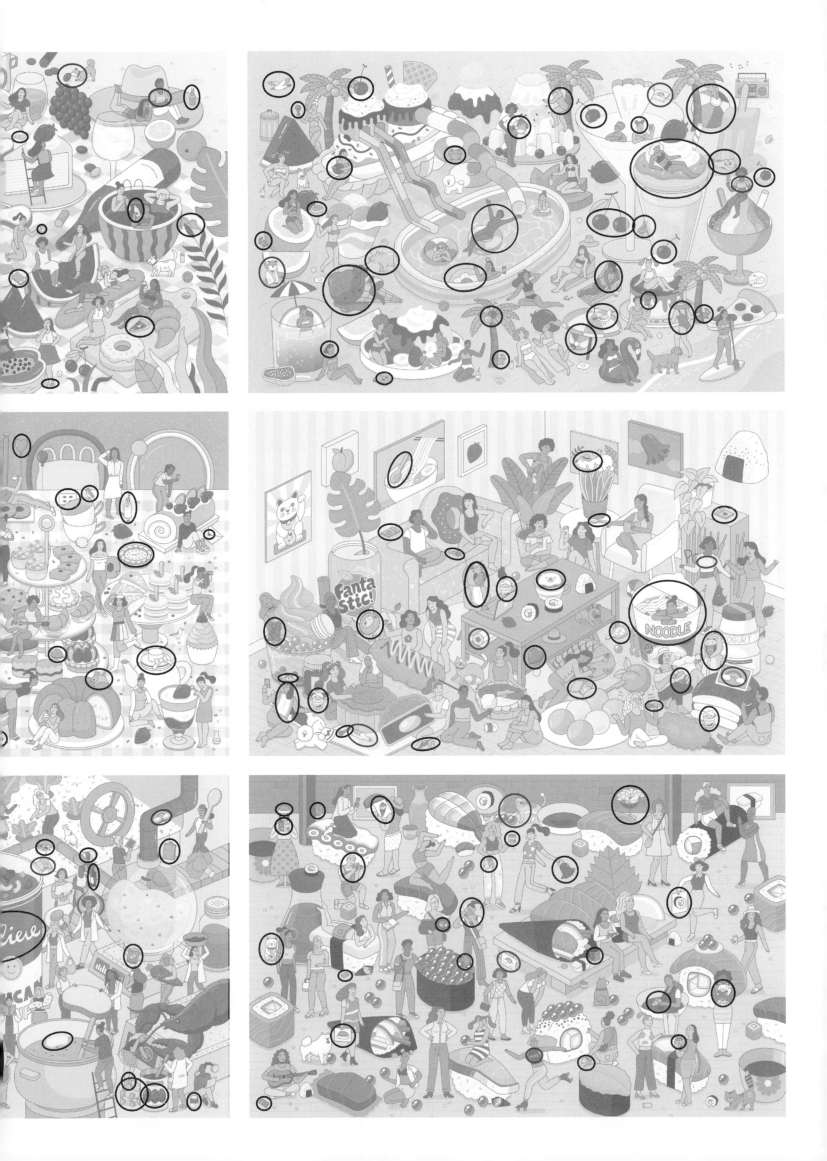

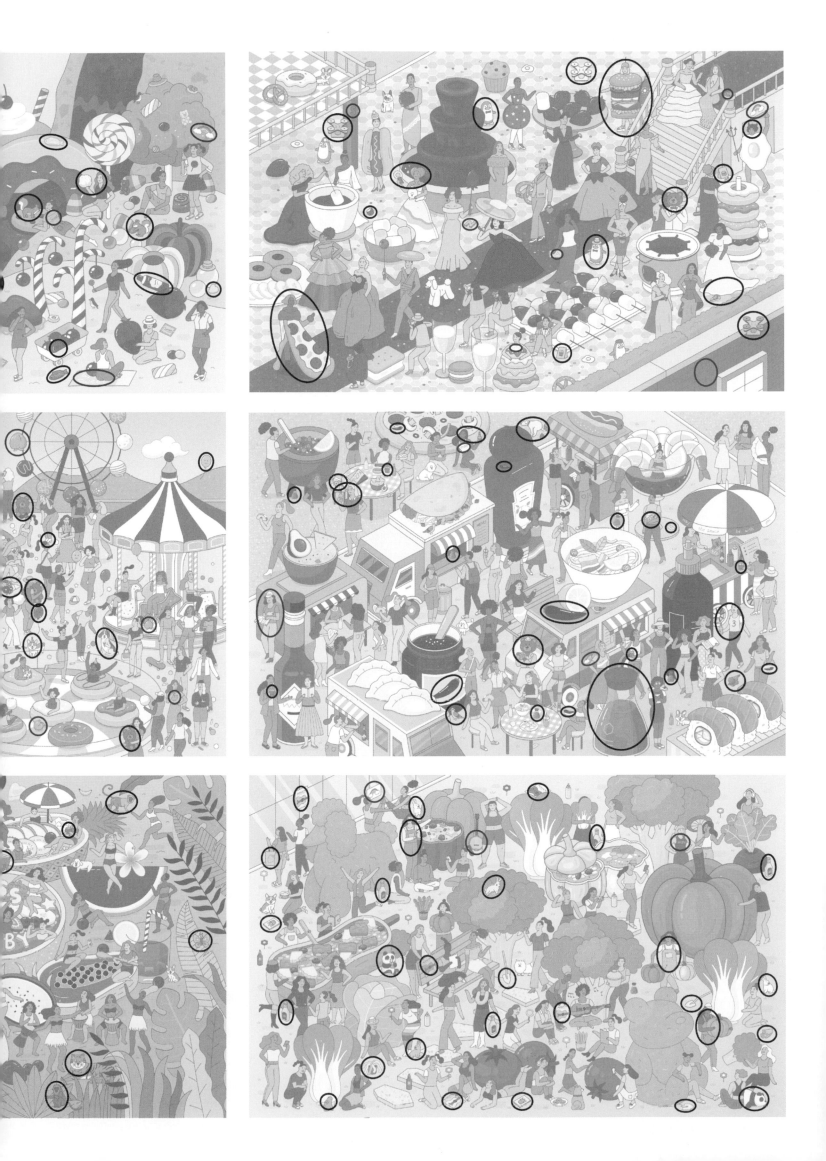

Library of Congress Cataloging-in-Publication Data available.

ISBN 978-1-7972-1384-2

Manufactured in China.

10 9 8 7 6 5 4 3 2 1

Chronicle books and gifts are available at special quantity discounts to corporations, professional associations, literacy programs, and other organizations. For details and discount information, please contact our premiums department at corporatesales@chroniclebooks.com or at 1-800-759-0190.

Chronicle Books LLC
680 Second Street
San Francisco, California 94107
www.chroniclebooks.com